UXBRIDGE COLLEGE LEARNING CENTRE
Park Road, Uxbridge, Middlesex UB8 1NQ
Telephone: 01895 853326/8

Please return this item to the Learning Centre on
or before the last date stamped below:

2 0 FEB 2002		
14 march	2 4 MAY 2005	
2 2 MAY 2002	1 4 DEC 2005	
- 8 OCT 2002	2 8 MAR 2006	
- 6 JAN 2003	0 NOV 2007	
2 7 JAN 2003	0 7 NOV 2007	
- 8 OCT 2003	1 1 DEC 2007	
2 8 JAN 2004	2 8 JAN 2014	

LEARNING RESOURCES AT UXBRIDGE COLLEGE

New British Art
IN THE SAATCHI COLLECTION

Alistair Hicks

with 211 colour illustrations

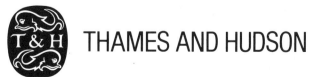

THAMES AND HUDSON

A NOTE ON ILLUSTRATION MEASUREMENTS

All measurements are given in inches (followed by centimetres in brackets). For paintings, height precedes width; for sculptures, measurements are given in the order of height × width × depth, unless otherwise stated, when the abbreviations h. (height), d. (depth) and dia. (diameter) are used.

ACKNOWLEDGMENTS

Julia Ernst, Rebecca Llewelyn-Jones and Janice Blackburn at the Saatchi Collection have done much of the work for this book. I thank them for their friendly and efficient help at every turn. I am grateful to Thames and Hudson for the sympathetic treatment of the text. My wife, Rebecca, not only did considerable research but has read and re-read the text along with Lord Horder. I thank Jennie Francis and Stephen Camburn for making it possible for me to write the book. I have been supplied with essential catalogues and information by Judy Adams, Kate Austen, Harriet Berry, Valerie Beston, Nicola Jacobs, Mary Lawrence, Nicholas Logsdail, Elizabeth McCrae and Geoffrey Parton. Finally and certainly not least the artists themselves have suffered my questions with great patience and by their work ensured that the book was a great joy to write.

3589

Contents

Art history meets art 7

School of London 11

New British Sculptors 16

The Painters

Michael Andrews 22

Frank Auerbach 26

Patrick Caulfield 34

Lucian Freud 38

Howard Hodgkin 46

R.B. Kitaj 56

Leon Kossoff 60

Lisa Milroy 72

Malcolm Morley 80

John Murphy 88

Avis Newman 94

Paula Rego 98

Sean Scully 102

Carel Weight 108

Victor Willing 114

The Sculptors

Tony Cragg 122

Grenville Davey 132

Richard Deacon 136

Julian Opie 146

Richard Wentworth 150

Richard Wilson 154

Bill Woodrow 156

General Bibliography 164

Biographies 165

Index 168

Art history meets art

Artists and art historians have traditionally been at loggerheads. Artists have kicked against the theories that pigeon-hole them neatly for future generations' easy digestion. Academics have been irritated by living artists' often highly personal interpretations of art history. War was inevitable, but the partial collapse of the linear view of art history has paved the way for a new understanding. Uncannily, with their emphasis on individuality, opposition to the group mentality and their direct response to everyday life, the painters of the School of London and the New British Sculptors have pre-empted advanced art-historical thought.

The New British Sculptors and the School of London might appear to many to be totally disparate groups, but although it would be wrong to indulge in too many comparisons, they both evolved in similar circumstances. The sculptors emerged from behind the blank wall conceived by the Conceptualists and erected by the Minimalists. The School of London was born when Abstract Expressionism was thought by some to have put the full stop on the act of painting.

Neither the School of London nor the New British Sculptors are art movements. The artists that make up these loose groups share a few common concerns but are not bound by manifestos or unifying theories. This partly explains the delayed international success of the painters. Lucian Freud received early acclaim, though he had to wait until 1987 for his first American exhibition in a public gallery.[1] Michael Andrews, Frank Auerbach and Leon Kossoff emerged in the fifties and sixties, R.B. Kitaj in the sixties. Howard Hodgkin and Victor Willing blossomed in the seventies, and it was as recently as 1976 that Kitaj coined the term School of London.[2] Apart from Francis Bacon, who gained widespread recognition with *Studies for Figures at the Base of a Crucifixion* (1944), significant international acclaim only came in the eighties. On the world stage they were overshadowed by Pop Art and a succession of -isms: Minimalism, Super Realism, Conceptualism and Neo-Expressionism.

Art historians' desire to look beyond an endless succession of -isms partly derives from a certain staleness of terms. Every generation cannot cry 'Renaissance' with posterity's blessing. Sir Herbert Read wrote of a renaissance in London's Hampstead as early as the thirties. He saw artists emerging 'out of the slumbering provincialism that had characterized British art for nearly a century'.[3] The War dispersed the artists of Unit 1,[4] so Read should not perhaps be judged too harshly. Certainly Henry Moore's and Barbara Hepworth's continued success helped four subsequent waves of British sculptors achieve a higher profile abroad than British painters.

'It seems to me more than likely', wrote Alan Bowness in 1966, 'that we are now witnessing in this country, here and now, one of the great epochs in the history of art.'[5] As most of 'The New Generation'[6] to whom Bowness was referring have now fallen slightly by the wayside, it is easy to contradict the critic and teacher who was later to be the director of the Tate Gallery, but he was not alone in this view and future generations may agree with him. Certainly the all-powerful American critic, Clement Greenberg, agreed when he wrote, '"Breakthrough" is a much-abused word in contemporary art writing, but I don't hesitate to apply it to the sculpture in steel that Anthony Caro has been doing since 1960.'[7]

Greenberg disregarded the niceties of terminology in order to stress Caro's importance, and though Caro has since suffered many critical onslaughts, he will probably win the day. People still argue over whether he was responsible for taking sculpture off the plinth, but he has undoubtedly had a strong influence, sometimes negative, sometimes positive, on younger sculptors. He inherited David Smith's mantle with Greenberg's blessing. In 1960 he set up a soldering workshop in St Martin's School of Art in London, which helped to make it the hub of sculptural activity for several years. He gained disciples like Philip King, Tim Scott and William Tucker, while Richard Long, Barry Flanagan, Bruce McLean and Gilbert and George reacted violently against him. Of the New British Sculptors, Richard Deacon and Bill Woodrow studied under him. Deacon had a positive reaction, but the others have adopted a much more distanced attitude.

The ambivalent relationship between the New British Sculptors and Caro is an obvious example of artists demonstrating their lack of faith in the linear development of art. Indeed, given the vivid and immediate response to their environment and times, there is a temptation to see Bill Woodrow, Tony Cragg and Richard Wentworth purely in social-historical terms, but this would greatly diminish their work. They have found a balance between the everyday world and art, as we should do when we look at their work.

The New British Sculptors confronted the Scylla and Charybdis of Conceptualism and Minimalism, an impasse which forced Woodrow and Wentworth to stop making sculpture for several years in the seventies. Deacon spent a crucial period in America (1978–79) when he reduced his output to drawings. It was not until 1978 that Cragg produced New Stones – Newton's Tones (Arts Council of Great Britain, London), which was an effective declaration of independence, undercutting Richard Long's grand statements by making a rectangle of garish plastic debris on the floor. There is an acceptance of Conceptualist achievement, for Cragg acknowledges that we live in our heads and talks of 'expanding one's brain', yet he gives it some concrete objects on which to work.

Cragg's choice of subject-matter and materials is not a crude preference for the urban against the rural. Indeed he emphasizes the way industrial products echo nature. He is interested in the synthesis between nature and the man-made. He is not prepared to go on one of Long's idyllic walks. He shows what is happening to man and nature; he makes sculptures that show how the world

is. He is an existentialist: he is not happy with rules, as soon as they appear he breaks them. It is a common trait among both the New British Sculptors and the School of London. There are very few shared rules. The determination to create their own individual language is one of the only undisputed links between them.

Another connection is a sense of man's isolation, which is a burning issue with Britain's painters and sculptors. British indifference to the visual arts has had more than an economic effect on artists; it has forced them to rely on themselves and confront their circumstances. For twenty years or more the School of London painters had enough support from a small group of loyal collectors, dealers and critics to keep them painting. They were and are highly philosophical. 'It is undignified of painters to complain about the lack of appreciation', says Auerbach. He even finds 'something quite bracing in being somewhere where painters are not categorized'.[8] Although their story is different in that much of their initial acclaim and support has come from foreign curators and collectors, several of the young sculptors take up the same theme.

'There is general indifference to living art in this country – an indifference not shared in Europe', writes Richard Deacon, one of the leading New British Sculptors. 'In some respects this makes Britain a very good place to produce art in – the indifference means that one can do what one likes. The negative aspect being that it doesn't matter very much.'[9] Antony Gormley, another New British Sculptor though not represented in the Collection, also highlights the isolation of the British artist. 'In my own experience,' he writes, 'I have not yet found, perhaps I still have to find, that brotherhood, that fellowship, that would allow me to make my work with other artists and be able to exhibit it in a genuine group.'[10]

The British art in the Saatchi Collection is not limited to that of the School of London and New British Sculptors. It is after all a living, ever-changing collection not tied to any one theory of art. Carel Weight is from the old English school of eccentrics that even long ago was thought beyond categorization. The ties to site hold Richard Wilson slightly apart from the other sculptors, who probably have more in common with the painters John Murphy, Lisa Milroy and Avis Newman in confronting the Minimalist/ Conceptualist impasse. Patrick Caulfield was included in Kitaj's 1976 exhibition, 'The Human Clay', so will be classed by some as School of London. He was called a Pop artist, but the allusive, shifting nature of his art is designed to avoid any classification. Sean Scully, who currently lives primarily in New York, is one of the few artists anywhere in the world to have recently injected new life into pure abstract art. Malcolm Morley, who also lives in New York, provided a vital bridge between American and European art when it was most needed.

In the context of the whole Saatchi Collection, of which the British art is but a fraction, Morley's inclusion is unsurprising. The Collection has become famous for introducing art of international importance into Britain. The surprise lies in the possibility of telling the story of the School of London and

the New British Sculptors with only a few references to artists and works outside the Collection. There are still some vital gaps. The Collection is not comprehensive, but its very existence is a sign that the British indifference to the visual arts is undergoing a severe test.

1 Hirshhorn, Washington 1987.

2 In the catalogue introduction to his exhibition, 'The Human Clay', which included some thirty-five artists working in or around London. I mention here the same nucleus that I discuss in *The School of London: The resurgence of contemporary painting*, Phaidon, Oxford 1989.

3 Marlborough Fine Art catalogue, London 1965, *Art in Britain 1930–40*.

4 Moore, Hepworth, Nash and Nicholson were among the founder members of the North London group Unit 1, which was lent weight by the arrival in the area of Gabo, Gropius and Mondrian.

5 Battersea Park, London 1966, *Sculpture in the Open Air*.

6 The New Generation of sculptors was centred around Caro and included David Annesley, Michael Bolus, Philip King, Tim Scott, William Tucker and Isaac Witkin.

7 *Arts Yearbook 8: Contemporary Sculpture*, 1965. Reprinted in *Studio International*, September 1967.

8 From a conversation with the author on 21 May 1986.

9 Hayward and Serpentine Galleries catalogue, London 1983, *The Sculpture Show*.

10 Ibid. 9.

School of London

London is a natural habitat for the isolated man. It is a sprawling city: Greater London gives shelter to nearly seven million people spread over some fifteen hundred square kilometres.[1] It is usually possible to ignore one's neighbours. The direct meeting of minds is not encouraged. The architecture, weather and temperament of the people conspire to keep the brain indoors. It is not a café society. There is no evening, arm-in-arm *passeggiata*. Though well-endowed with galleries, museums and theatres, the city boasts no intellectual meeting places. The artist is forced back to his studio with a vengeance.

The School of London painters are certainly not hermits in the traditional sense. The Colony Room, a Soho drinking club, is associated with them. It has their paintings adorning its green walls; there is even a faded mural by Michael Andrews. Francis Bacon and Lucian Freud are notorious for their good living. 'One is now unaccustomed to a daemon like this in the polite community of the visual arts,' writes Sir Lawrence Gowing in his monograph on Freud, 'but in the past art was full of such people. This is how young men of the Renaissance must have been, with their eyes on anatomy and the main chance, on the street corners at evening when the *botteghe* came out and the virgins were hurried indoors.'[2] Kitaj was once a merchant seaman and his writings are littered with talk of brothels. Nor can the lives of Michael Andrews, Frank Auerbach, Howard Hodgkin, Leon Kossoff and Victor Willing be described in terms of celibate sobriety, yet the eight principal School of London painters have all devoted a legendary passion and time to their work. Freud paints through the night and is reputed to need only two hours' sleep.

The history of the School of London extends back well beyond Kitaj's coining of the phrase in the catalogue introduction of his 1976 exhibition at the Hayward Gallery, London. In 'The Human Clay', the American-born painter chose thirty-five painters and the then 'unfashionable' human figure was the subject. It was a prophetic show. 'There are ten or more people in this town, or not far away, of world class', he writes. The show and the essay did not bring instant international recognition, but it was another vital blow to London's earlier provincial attitudes, which were gradually being suffocated as refugees from Europe, who had fled from Fascist and Communist persecution, exerted their influence.

As Auerbach, Freud and Kossoff developed their art, London rebuilt itself. Kitaj, who was born in Ohio and wrote the *First Diasporist Manifesto*, has termed them Diasporists: Auerbach and Freud were born in Berlin, Kossoff's parents came from Russia. All three have painted the derelict land left after the bombing as well as many other views of the city. Kitaj himself has tackled the subject of London far more indirectly.

Not one of Kitaj's five paintings in the Collection are set unequivocally in London. *The Corridor (After Sassetta)* (1988) echoes *Cecil Court, London WC2 (The Refugees)* (1983–84, Tate Gallery, London) but even that homage to London's itinerant book people refers in its turn to Balthus' Paris. Kitaj reveals his fragmentary vision with remarkably little recourse to his adopted home. As he wrote in the catalogue introduction to 'The Human Clay', 'Each one of you who reads this, conducts his or her very complex affair with London and yet how often does our art look as if it had been made here?' Paris, Vienna and that most dispersed of cities, Los Angeles, provide more fruitful ground. David Hockney, as represented in the *The Neo-Cubist* (1976–87) is set against the lush environment of his Los Angeles home. Kitaj planned to join Hockney in Los Angeles. *The Drivist* (1985–87) provides one of the reasons he didn't move there. He no longer drives and his attempts at walking round the city were treated with bemusement. He returned to London where he has finally resolved to stay. Despite being a resident for nearly thirty years he is still a displaced person. The consolation is that he has been left alone in his studio to paint pictures.

Unlike the Unit 1 artists of the thirties who were mainly huddled around Haverstock Hill, the School of London painters have their studios scattered across London. Kitaj is in Chelsea, Bacon is in South Kensington, Freud's rooms are perched above Holland Park, Auerbach is near Primrose Hill, Hodgkin is in Covent Garden, Kossoff lives and works between Willesden and Kilburn in the north-west and Dalston, Hackney and Bethnal Green in the north-east.

'My studio is like a field,' Kossoff writes, 'a field in a house. Muddy hillocks of paint-sodden newspapers cover the floor burying scraped off images. Derelict boards stand in all corners, remnants of recent activity. Yet, down there in the mess on the floor a little head of Heinz looks back at me. Can I leave it now after all this time? And those other boards lying there, Fidelma before going to Kiev, Peggy and John, Chaim only almost emergent, and Kilburn Underground, half there, which is not there.

'My dialogue is with these discarded images left on the floor', Kossoff continues. 'The subject, person or landscape, reverberates, in my head unleashing a compelling need to destroy and restate. Drawing is a springing to life in the presence of the friend in the studio or in the sunlight summer streets of London from this excavated state and painting is a deepening of this process until, moved by unpremeditated visual excitement, the painting like a flame, flares up in spite of oneself, and, when the sparks begin to fly, you let it be.'[3]

The painters have been loyal to their studios. In recent years Auerbach, Bacon and Kossoff could easily have afforded to move into larger premises, but have preferred to stay in their old paint-spattered places. 'I feel at home here in this chaos because chaos suggests images to me', said Bacon to David Sylvester about his studio and home since 1961.[4] It shows his Nietzschean disdain for order and yet he is the first to realize that one needs order to show chaos.

Freud does not mock order like Bacon, but shows the narrow dividing line between order and chaos. The *Naked Man on a Bed* (1987) is displayed

clinically, on a bed nearly square on to the viewer. Though curled up, the man neatly bisects the picture horizontally. He is presented with a formal precision and yet a pile of crumpled cloths, which the artist uses to wipe his brushes, fills the top-right corner of the canvas. These same clotted cloths appear in many of his paintings.

Auerbach talks of the 'chaos and atmosphere' of the London streets. He has organized his life so that he can best record this and other passing experience. He has been in his studio for thirty-five years. He has a bed there, but his paintings prove that he does leave the studio. Every painting of Primrose Hill, for example, demands hundreds of drawings from life.

There has been and still is a complicated web of friendships and connections between the painters, but they are a far from cohesive group. Indeed the camaraderie of the early days, when most of them showed at Helen Lessore's Beaux Arts Gallery or the Hanover Gallery, has probably been overplayed. In 1962 *Vogue* published a now famous photograph showing five promising painters at Wheelers' restaurant in Old Compton Street. Bacon, champagne glass in hand, is talking to Freud, while Auerbach and Andrews are having a more subdued conversation. Timothy Behrens is left to contemplate his empty plate at the end of the table. It is a totally posed photograph. The artists were given the one bottle of champagne and then departed their separate ways. The new moves in art history have not stopped the desire for artistic groups, nor indeed the delight in myths about the lives of artists.

The ability to create their own individual pictorial language has been the first requirement, but there are other similarities between the School of London painters. They have demonstrated a wholehearted commitment to painting through times when the very process was considered archaic. Auerbach, Freud and Kossoff have gone one stage further, displaying a new faith in paint itself. The depth of paint in early Auerbachs and Kossoffs encouraged a barrage of comment on technique, so today the artists tend to play down their use of materials, but their trust in the medium to yield images is important. 'When one pushes the paint in a certain way,' says Auerbach, 'it seems almost to drag one in its wake.'[5] Freud has the highest expectations of paint. He wishes to transform it into the very flesh of his sitters. The paint has to become flesh. Freud's harsh gaze at the human body recalls the words of William Blake:

Why a tender curb upon the youthful, burning boy?
Why a tender little curtain of flesh upon the bed of our desire?

Freud chose realism as the most effective method of making people look again at the world. He is not interested in mere representation, but like most of the School of London painters he has found a way to convey heightened emotion on canvas.

Kitaj strikes a discordant note in the School of London. He may have rebuked the world for not giving the London painters the attention they deserve, but he also demands that they should not be explained away by a few stylistic connections. Bacon had shown that it is still possible to concentrate emotion within the canvas and Auerbach, Freud and Kossoff follow his

example. Kitaj does the opposite: as a Diasporist, he disperses the image and builds up the impact out of scattered elements. In his sweeping depictions of sixties' society, such as *The Deer Park* (1962, Tate Gallery, London) and *All Night Long* (1963–64, The National Gallery of Victoria, Melbourne), Andrews has a similar ambition, but not for the same reasons. Hodgkin, however, is walking a parallel path. As his abstracted language has matured it has grown more and more cohesive, but it never relies too heavily on one part of speech. Like Kitaj he is tackling the unresolved legacy of the Cubists.

In his double portraits and other interiors, Hodgkin pursues the recurring theme of man's character and relationship to his environment. His subtle juggling of textures and exploitation of illusion present a vision of modern life far removed from the stark disrupted figures of Bacon. Bacon creates frameworks for his men and women. His box structures act like gym bars on which the human body balances and the emotions perform, sometimes literally in the shape of swinging, screeching Eumenides.

Elsewhere I have argued that the School of London is not a movement but a stream of painting, that it is not restricted to the accepted core of six or seven painters but extends over three generations and may influence even more.[6] I include Willing in a first generation of eight, but count his wife, Paula Rego, as a revelatory figure in the second generation. Willing comes out of the very English Slade School of Fine Art, yet with the example of Francis Bacon before him and years of mounting frustration, he was able literally to burst out of the confines of the studio, punch a hole through its walls and create a new art.

The distrust of order has been the sign of many great thinkers and, since the Enlightenment, has almost gained respectability. It is surprising that art theoreticians do not appear to have progressed far in this line since the good start given by Diderot, Baudelaire and Apollinaire. Certainly Cubism was born out of a severe questioning of the supremacy of the eye. The collapse of French dominance in the visual arts coincided with the emergence of a Modernism with a near Platonic belief in order. In this respect School of London painters owe their allegiance to France, thus avoiding the Greenbergian heresy. Bacon acknowledges a debt to Baudelaire through Michel Leiris. 'We can call "beautiful" only that which suggests the existence of an ideal order,' wrote Leiris, 'supra-terrestrial, harmonious and logical – and yet bears within itself, like the brand of an original sin, the drop of poison, the rogue element of incoherence, the grain of sand that will foul up the entire system.'[7]

It is doubtful whether Leiris' definition of beauty would satisfy all members of the School of London. To a certain extent every one of the artists is a 'rogue element'. The group cannot satisfactorily be explained by an artistic lineage, nor should they be seen purely as a product of their age. They are called Pluralists and Post-Modernists, but these negative terms are unsatisfactory. From the works in this Collection, it is possible to see how Hodgkin has built up a pictorial language over the last thirty years. He has refused to be bullied into an instant reaction for or against his immediate artistic precursors, but has rather re-examined twentieth-century art history and has built up a new art that has grown along paths parallel to others, but never the same.

For those who divide artists into Modernists and Post-Modernists, Hodgkin presents a target. He appears blatantly Post-Modernist in his raid on Baroque illusionism. He is prepared to trick the eye at every brush stroke if it will help break down barriers between the picture and the viewer. His insistence that his paintings are based on specific events appears to be a deliberate insult to late Modernism, but the split between Modernism and Post-Modernism is as irrelevant as that between the abstract and the figurative. Hodgkin and the other School of London painters are not art magpies. They simply use their knowledge of art history, their visual memory, to respond to the experience of their age.

There is an irony in London becoming a haven for artists. It has done little to attract them. Its art schools have provided training and valuable part-time employment to most of the School of London, although Bacon did not attend even one. The main reason why London is a centre for artists today is that it leaves its artists alone. Two painters in this book, Malcolm Morley and Sean Scully, have been driven from the country by its laid-back antagonism to artists, yet Scully now spends his summers in London, because he finds he can do more work here than in New York.

London has done what Paris and New York did before it. It has attracted foreigners, assimilated them and called them its own. This continued after the war. Paula Rego is Portuguese. At the age of seventeen she came to the Slade, where L.S. Lowry was one of her visiting tutors. On first seeing her work, he burst out, 'I wish I could do that.' Sadly the response has not always been as spontaneously warm, but there is now an important community of artists in London. They are probably not any more or any less isolated than everyone else in this city, but the results are more eye-catching.

1 6,770,400 people over 1,579 sq. kms (Department of Environment 1987).

2 Lawrence Gowing, *Lucian Freud*, Thames and Hudson, London 1982.

3 Anthony d'Offay catalogue, London 1988, *Leon Kossoff*.

4 David Sylvester, *The Brutality of Fact – Interviews with Francis Bacon*, Thames and Hudson, London and New York 1987.

5 From a conversation with the author on 21 May 1986.

6 Alistair Hicks, *The School of London: The resurgence of contemporary painting*, Phaidon, Oxford 1989.

7 Bacon recalls ringing this passage in a small book by Leiris.

New British Sculptors

'Poetry is made of ordinary language', says Richard Deacon.[1] The ability to cut through pretension has helped the New British Sculptors achieve unrivalled international success, though they never intended to be a group and have for nearly a decade successfully fought any attempt to define their aims.

New British Sculpture emerged in a series of exhibitions at the beginning of the eighties. 'Objects and Sculpture', at the Institute of Contemporary Arts and the Arnolfini in 1981, was the most important,[2] yet there was a reluctance even in those heady days to pin down the group. 'This exhibition is not intended to define a new "group" or "movement" among artists working in Britain today', wrote the organizers. They were prepared to point out that the exhibiting sculptors valued 'truth to process' more than 'truth to materials' and to conclude with a poetic flourish, 'The thunder clouds of an over-self-conscious avant-garde in sculpture have rolled away to reveal a clearer sky.'

Only two of the sculptors in the Collection, Bill Woodrow and Richard Deacon, showed at the 1981 exhibition, but Anish Kapoor, Edward Allington and Antony Gormley were represented and should not be excluded from an assessment of New British Sculpture. Tony Cragg had a one-man show earlier in 1981 at the Whitechapel Art Gallery and had shown at the Arnolfini the year before. Shirazeh Houshiary and Alison Wilding exhibited together at Kettle's Yard early in 1982. The Collection also contains work by two others to have been dubbed New British Sculptors, Richard Wentworth, who is the oldest (born 1947) and the youngest Julian Opie (born 1958).

There are many connections between members of the group, but very few that extend to them all. Their varied and extensive training exemplifies this. The sculptors are often associated with St Martin's School of Art, but only Woodrow and Deacon went there, while Cragg, Deacon, Wentworth and Wilding attended The Royal College. Deacon was a student for eight years, also attending Chelsea, as did Woodrow and Kapoor. The more one delves the more complicated the pattern becomes.

It is possible to talk of shared concerns between the sculptors, such as a direct approach to their surroundings, a responsibility for the environment and a desire to rise above materialism, but even in a discussion of these broad topics there will be objections from some corner. There is invariably at least one sculptor who doesn't fit a particular theory.

Assessing the work of the New British Sculptors as a group is like entering a room full of strangers. Connections soon emerge between groups of people within the room. It is even possible to make tenuous links between them, but by the end the propositions are changed beyond recognition. The only undisputed conclusion one can reach is that the men and women shared a location at a specific time.

'I wish to make sculpture about belief,' says Kapoor, 'or about passion, about experience, that is outside of material concern.'[3] The sculptors share a desire to rise above materialism, but Kapoor's and Houshiary's spiritual approach to man's relationship with his environment is in stark contrast to most of the others' brutal realism. As is often the case Deacon supplies the missing link. His sculpture, like any language, acts as a bridge between man and understanding. The precise, organic forms appear to reflect nature, but this is balanced, if not denied, by the basic industrial materials. The centres of his work reach the heights of abstraction, being made of air, but the solidity of the skeletal structures, the nuts and bolts of everyday existence, offer a handle, something tangible. His work is difficult to ignore.

Deacon is adamant that however much his works look like three-dimensional drawings they should not be read as ideal models. As with Cragg, Woodrow and Wentworth, nature may be important to his work, but the New British Sculptors are no longer in the grand landscape tradition that extends from Claude to Long. They have consciously broken the line. Cragg calls nature 'his first workshop', but as his work has developed he has gradually purged nature of the connotations heaped upon it by both Romanticism and Classicism.

Cragg, considered by most to be the intellectual leader of the group, departed to Wuppertal in the industrial heartland of Germany in 1977, leaving the rest of the group in London. Cragg's absence has not harmed the others' work. This not only underlines the amorphous nature of the group but stresses its international leanings. Apart from a familiar streak of humour the sculptors don't display any particularly British traits in their work. The isolation of the British artist has encouraged them to look abroad for support. They have been shown and sold abroad as much as in Britain. The sculptors are as likely to see each other at international shows as at home, although there is one important common venue in London: the Lisson Gallery.

With the exception of Gormley and Wilding, the sculptors are represented by the Lisson, which was a centre of Minimalism, Conceptualism and Land Art in the seventies. It represented Donald Judd, Sol LeWitt and Richard Long, among others. Several of the new sculptors were regular visitors to the Gallery and their early work was a reaction to it.

Cragg's leadership of the group has perhaps been over-emphasized. He has been inspirational and more prepared to talk to other sculptors about their work than Woodrow, but it is more accurate to see them both as the twin towers of the group. Cragg's *New Stones – Newton's Tones* (1978) makes a direct challenge to Long, but Woodrow had laid his claims to the leadership even earlier. In 1970 he constructed rocks of polystyrene, a piece entitled *Sleeping Sheep Rocks* (no longer in existence). He produced a film of a scythe-shaped stick flying through the countryside. In 1970 he made a Richard Long-type circle of pigeons in Soho Square, which flew away when they had eaten the grain beneath them. After his 1972 Whitechapel show he was without a studio until 1978, at which point he immediately started using everyday objects from his urban surroundings.

'Walks in the countryside and rural atmospherics don't play a very large part in my life', says Woodrow,[4] who sees nature as a fabrication. Wentworth was later to joke that he had never seen Long in the country. As Long and his contemporaries abandoned the cities and suburbia, there was a crying need for an art to confront the world we inhabit. David Nash asserts that his work goes hand-in-hand with his way of life. For him that has meant living in a remote Welsh town since 1967. 'We have a culture that looks at nature through windows,' he says, 'mainly out of car windows.'[5] The new sculptors are quite prepared to show what lies the other side of most people's car windows, and it is not Snowdonia, Kotoku or the Himalayas.

'Functionless design has severely affected people's capacity to judge the world in which they live', says Wentworth.[6] It is easy to mistake Wentworth's sculpture, photographs and words as successive outbursts of moral indignation at the way we treat the world, but morality is not a tool he would consider using. It is far too heavy-handed. Wentworth prefers to quip, *Glad That Things Don't Talk* (1982). The artist is asking for a reassessment of the way we lead our lives, but he refuses to preach. Instead he uses countless visual tricks, and an engaging awkwardness that rings true to the pattern of everyday living: the untidy sequence of events, the randomness of most of our lives, balanced and often pinioned by the stream of our expectations. By upsetting the latter the artist threatens to overwhelm the established order and throw us back upon ourselves. He stops short of total visual anarchy, checked by a responsibility to his audience shared with the other sculptors. This could be attributed to the influence of Peter Kardia, who taught Cragg, Deacon and Wilding as well as Wentworth at the Royal College. Wentworth describes him as the *éminence grise* of the group.

'We are living in a new epoch for sculpture', Cragg declares.[7] It is a freedom won for his generation by its immediate precursors, those who claimed new non-art materials for art: Judd, Flavin, Nauman, Long, Flanagan and Weiner. The expansive use of materials by the Italian artists of Arte Povera makes them forerunners too. Unlike Caro's New Generation, New British Sculpture was not born solely out of a response to American art and criticism, nor was it formed out of the backlash against America and Vietnam. However, a debate in America did prove important, even if ultimately it fuelled the frustration which was to burn slowly throughout the seventies.

The American sculptors, Donald Judd and Robert Morris, attacked and were counter-attacked by Greenberg and his disciples. A lengthy debate ensued in *Art Forum*.[8] Judd and Morris advocated the use of repetitive unit forms to maintain the 'wholeness' of sculpture. Repetition has never been fully adopted by the British sculptors, but Kapoor's pursuit of spiritual integrity in *1000 Names* (begun 1981) has a vague echo of Minimalist intention. On the other hand his belief that the whole can be extended well beyond a single object and his sprinkling of pure paint pigment place him closer to some Conceptualist work. Like Cragg and Wentworth, he is prepared to make works of art that need to be reassembled every time they are moved. There is still an element of installation in many of the sculptors' works.

Deacon is close to Judd in his emphasis on construction and the cohesion of the unit, but he leaps from the self-referential aspects of Minimalism. He does not make art for art's sake. He has created a sculptural language to describe the world and our affair with it. However much Deacon has learnt from Judd, he refuses to be inhibited by a set of rules. His forms abound in curves. Houshiary could almost be talking about his work as well as her own when she says, 'Asymmetry "breaks the mind" (in the sense that geometry is "of the mind").'[9] The order of the world, its structure and our response to it, both spiritually and physically, provide the subject-matter for the sculptors. Kapoor naturally makes use of his Indian roots, Houshiary her Iranian origins, while in *Ideal Standard Forms* (1980) Allington ventures into the forbidden territory of classical interpretations, though he comes down strongly against Plato's concept of beauty. 'My strongest objection to Plato', he says, 'is that he was always trying to bury . . . the cult of Dionysus.'[10]

Each of the sculptors works according to his or her own rules and perceptions, but as a group they do not share any taboos. Much has happened since Caro's St Martin's workshops. 'The St Martin's sculpture forum would avoid every broader issue, discussing for hours the position of one piece of metal in relation to another', Bruce McLean recalls. 'Twelve adult men with pipes would walk for hours around sculpture and mumble!'[11] The new sculptors are not preoccupied with formal concerns, but with a direct response to their surroundings and lives.

Cragg's near-scientific thoroughness and Woodrow's natural facility have propelled New British Sculpture on a path of constant reassessment. As no pretender has managed to take Joseph Beuys' crown following his death in 1986, it is tempting to claim it for Cragg, who has now become a Professor at the Kunstakademie in Düsseldorf like Beuys before him. Apart from rustling a few feathers in that German hothouse, this threat would achieve little. Cragg is not an art guru, nor would he want to be, but there are several similarities between Cragg and Beuys. They have both remained loyal to the belief that art can improve the world. Man, in their eyes, is capable of determining his future.

Cragg falls short of Beuys' Messianic zeal, but he is more realistic. Where Beuys was committed to a new social order, Cragg wishes to induce a responsibility for the environment. Like Beuys he wants to heal. It is the rift between nature and the man-made that receives his attention and he attempts a synthesis between nature and man. The tyres of his *Minster* (1987) are no longer debris, but a natural part of his vision. The emphasis is not on the recovery of the objects as it has been in much previous *Bricollage* art.

Art historical claims can be made for New British Sculpture, but the lines are diffused. The influence of Cubism is an obvious example. Wentworth has described Picasso's *Glass of Absinthe* (1914) as 'the best sculpture in the world'. Woodrow may have developed his own technique, but he creates new juxtapositions out of old objects in the spirit of Picasso. There are many threads between the new sculptors and Cubist collage, some are direct, but most are broken and knotted. The knives and scissors were most active in the sphere of Clement Greenberg.

Caro's connections with Cubist collage and the later metal constructions of Picasso and González are unmistakable. Greenberg expected sculpture to take up the modernist flag from the Abstract Expressionists. He looked first to David Smith, who was a friend of Pollock, then De Kooning, Motherwell and Noland, but Caro proved truer to Greenberg's ideas by making sculpture into a series of picture planes. This was vigorously attacked by Robert Morris who described painting as an antique mode. He declared himself 'dramatically opposed to Cubism with its concern for simultaneous views in one plane'.[12] After such arguments, Smith's much earlier declaration 'that there are no rules in sculpture'[13] is like a shaft of fresh wind from the past. In retrospect Smith looks an excellent role model for the New British Sculptors, but knowledge of his work has only confirmed their direction, as his reputation was in the shadows in Europe during the crucial seventies.

'In the early 1970s there was a proliferation of work directly concerned with expressing frustration,' writes Fenella Crichton, 'much of it was by students or ex-students of the Royal College.'[14] She then pointed to Wentworth's *Momentary Memento (Protected Accident)* (1974, private collection Barcelona), which shows a broken Yale key in a lock. Even if the key could open the lock and was not further restrained by a perspex and wire grid, which closely resembles much of the formalist work of the time, there is no door to open. Only a fragment remains. It leads nowhere.

The sense of frustration among young sculptors in the seventies helps to explain the explosive and direct nature of the New British Sculptors' response. Yet their full impact has yet to be felt. The nine mentioned in this chapter have never had a show together, though they came close to it in a Danish exhibition of 1986.[15] The failure to find a definition has protracted their influence. The group itself has the allusive qualities of some of their art. It keeps our interest by not yielding its secrets immediately.

New British Sculptors cannot retain their present name for ever, but it has lasted so long because of its very blandness. Even that does not satisfy everyone, for some object to being thought of as a group at all. If the group could be given a watertight definition it would be dead. The sculptors' resilience speaks of the life still within the group. Woodrow's work, for example, has turned a corner since 1987. He has resorted to making rather than finding much of his material. Opie's art has changed dramatically in the last few years, and though his work conformed in several ways to the loose spirit of the group a few years ago, it may well not conform tomorrow. Constant reassessment, one of the shared aspirations of the sculptors, could easily tear them further apart, rather than bring them together. If their sculpture remains as vigorous and uninhibited as it has been to this day we cannot ask for more.

1 From an unpublished interview for video made to accompany 'Entre el Objeto', Madrid 1986.

2 Institute of Contemporary Arts, London and Arnolfini Bristol, 1981, *Objects and Sculpture*. Introduction written collaboratively by Lewis Biggs, Iwona Blaszczyk and Sandy Nairne. Other than those mentioned it included Margaret Organ, Peter Randall-Page and Jean-Luc Vilmouth.

3 Ibid. 2. From quotes by the artists.

4 Ibid. 3.

5 *Aspects 10*, Spring 1980.

6 From an interview with Paul Bonaventura, *Artfactum*, September/October 1987.

7 From a conversation with the author on 25 April 1989.

8 The key arguments can be found in Robert Morris' *Notes on Sculpture* (in four parts starting February 1966) and Michael Fried's *Art and Objecthood*, Special Issue Summer 1967.

9 *Entre el Objeto*, Madrid 1986.

10 From an interview with Stuart Morgan in *Edward Allington: In Pursuit of Savage Luxury*, Midland Group, Nottingham 1984.

11 Nena Dimitrijevic quotes Bruce McLean in *Bruce McLean*, Whitechapel Art Gallery, London 1981.

12 Robert Morris 'Notes on Sculpture – Part 2' *Artforum 5*, October 1966.

13 *David Smith* by David Smith, ed. Cleve Gray, New York 1972.

14 Whitechapel Art Gallery catalogue, London 1981, *British Sculpture in the Twentieth Century*.

15 Louisiana Museum of Art, Humlebaek, Denmark 1986, *Sculpture: 9 artists from Britain*. It included Allington, Deacon, Houshiary, Kapoor, Opie, Wentworth, Wilding and Woodrow. Boyd Webb replaced Cragg who had blazed the trail by having a one-man show there in 1984.

Michael Andrews

'Michael Andrews for a long time led a double life at the easel', wrote John Russell in 1965 in *Private View*. 'Passages of real lyrical beauty alternated with others patently awkward or unsuccessful', he continued. Little but the time cycle has changed. There are troughs in Andrews' work. He was not fulfilling his early promise until he produced the 1983–86 series of paintings based on Ayers Rock. The subject-matter, technique and mood were out of step with the other School of London painters, yet the paintings are awe-inspiring. Is it such a wonder that the artist shows the rock laughing?

The luscious lips in *Laughter* (1985) are formed by a cave. Every mark on the surface of the rock has a religious significance to the aborigines, which has undoubtedly influenced Andrews. The flagship of the series is called *The Cathedral, North-East Face* (1985) and the exhibition of the works 'Rock of Ages Cleft For Me'.[1] Though he travelled to the other side of the world in the expectation of being impressed by the rock, he didn't predict that he would 'be choked with emotion'. Back in his studio, a converted chapel in his native Norfolk, with a spray gun in hand, the hymn and the memory of aboriginal lore in his mind, there is more than a hint of art replacing the experience of religion.

There were several stages between Andrews' visit to the Rock in October 1983 and the final paintings. He projected photographs of watercolours on to his canvas. The watercolours in their turn were often prompted by photographs. His method pulls two ways. It builds up an image out of repeated images, out of an ever-increased knowledge of the subject, which at the same time becomes further distanced by every stage. The size of the rock demands its own treatment; it refuses to yield its secrets in one sweeping view. In *The Cathedral, North-East Face* the artist has the viewer looking back and forwards. On the right-hand side of the painting there are three dots, three people.

The eerie stillness of *Permanent Water* (1985–86) seems to demand the smooth sprayed surface of the other works, but Andrews has let the paint drip and bubble. The threatening rock-faces clash together above us. The artist has always been prepared to take risks, but an unmanageable geological freak basking in the sun of the Southern Hemisphere challenged the very roots of his art, which seemed buried deep in the British landscape and figure. He has emphatically risen above any earlier tendencies towards provincialism. He might even be leaving behind his double life.

1 At the Anthony d'Offay Gallery, London 1986.

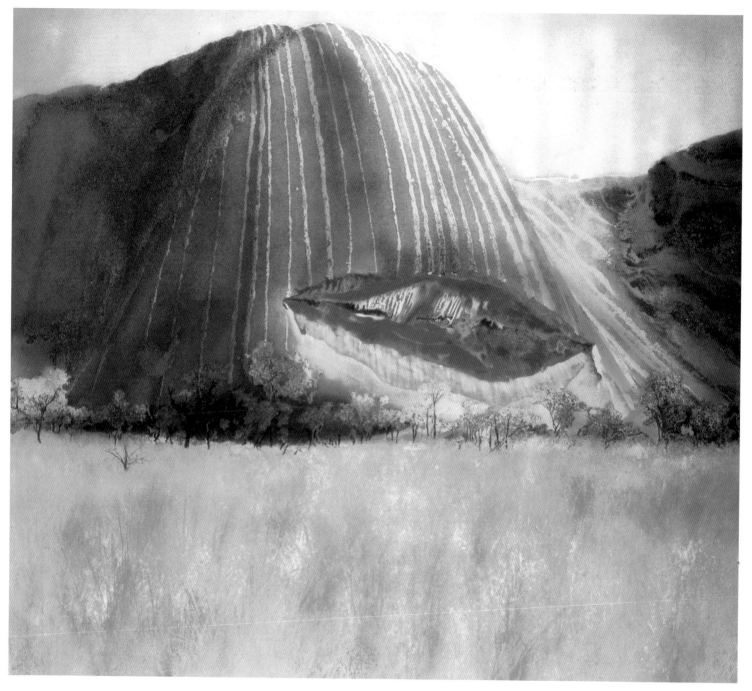

1
Laughter Uluru (Ayers Rock)
1985
Acrylic on canvas
96 × 108 (244 × 274.3)

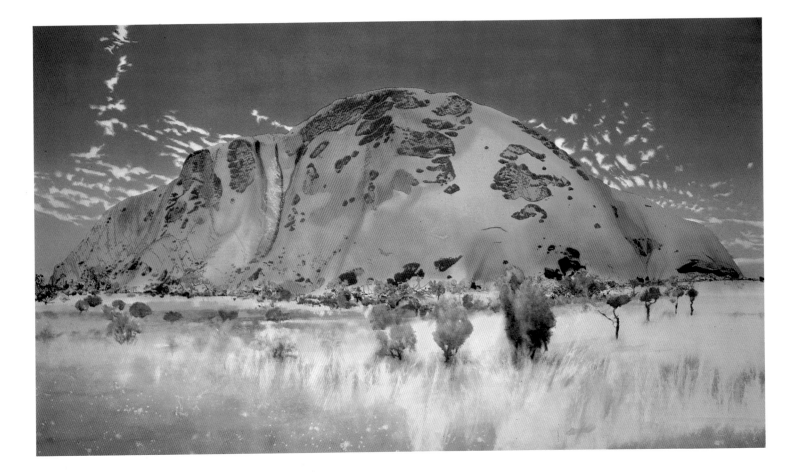

2
The Cathedral, North-East Face Uluru
(Ayers Rock)
1985
Acrylic on canvas
96 × 168 (244 × 426.7)

3
Permanent Water Mutidjula, by the Ku
(Maggie Springs, Ayers Rock)
1985–86
Acrylic on canvas
84 × 102 (213.4 × 259)

Frank Auerbach

Work and life are virtually inseparable to Frank Auerbach. 'My first consideration on getting up in the morning every day of my life has always been about painting', he says.[1] His working method consumes his life. He works and reworks until the paint produces a spontaneous image to justify the accumulated labour. The results have made him a pillar of British painting, yet the opportunities to study his evolution as a painter have been rare.

Auerbach's work has passed through many stages. In the fifties and sixties, his paintings progressed through browns, a series reduced to black and white and several subsequent bursts of colour. The application of paint underwent equally dramatic changes. Even today he is known by many for the thickness of his paint, yet he stopped producing deep fields of paint about thirty years ago. However, the consistencies in his work are more surprising than the differences. He invented a system of painting for himself back in the mid-fifties, which has allowed him to explore his relationship with his immediate surroundings in startling detail.

Primrose Hill (1954–55), Auerbach's earliest painting in the Collection, was started when he was still a student at the Royal College of Art, London, soon after he moved to his present studio which is close to the hill. It is the second painting of a subject that he has continued to treat over more than thirty years. He wanted to find a new idiom so that he could present his subject in a 'raw and direct' manner, in contrast to much of the flat and linear work of the time. He achieved this through a series of highly specific drawings of the paths, buildings, trees and even the lovers in the bottom-right-hand corner of the painting. Its thick paint yields up its image as grudgingly as its monochrome clay colour suggests, but once perceived it is as precise as a Northern Renaissance engraving.

While the Collection does not contain any later depictions of Primrose Hill, other landscape subjects and portraits reflect the changes that unfold over the years. It is occasionally assumed that Auerbach's reliance on a limited group of subjects and his endless repetition of them must lead to repetitive work. Yet his technique was devised precisely to combat any suggestion of sterility. His intimacy with the people and views he paints ensures that he is open to new possibilities, that he will risk everything to find new ways of geometrically binding his compositions. By pinning his work so closely to his life he has made certain that he will never run out of subject-matter.

It took Auerbach nearly thirty years to realize that J.Y.M., once a professional model for him but now a friend, instinctively turned her head to the left or right when sitting. In *Head of J.Y.M.* (1986) he rectifies this and she confronts the viewer full on. It is a far cry from *Figure on a Bed* (1969): 'At first, when I did not know her so well', he remembers, 'she sat mainly in the nude

and I would paint my studio, using her presence as an animating element to give myself a motive for doing so.'

Auerbach is by nature a shy man, and he has learnt to harness the intensity of his emotions, transferring them into paint. Shared experience with a woman with the initials E.O.W. was crucial in this process. He painted her three evenings a week from 1952 to 1973. The Collection's *Head of E.O.W.* (1955) is a by-product of a larger painting of the same title and date owned by the University of Cincinnati, which took over three hundred sittings to complete. He says that he can often be more reckless in the smaller works, but eight years later a bolder, more positive mood prevails anyway in *E.O.W. III* (1963). 'I could afford brighter colours', he recalls. 'I might have begun to feel that my work was a bit static and wanted to rattle the bars of my cage.'

Auerbach's response to man's imprisonment is highly philosophical and yet wild. His approach to painting borders on the scientific. His drawings are like a series of experiments, preparing him for the ultimate laboratory test. Time sits on his shoulder. He is attempting to pin down passing experience, so cannot afford to break the atmosphere created by one session. The final picture has to be completed within one drop of time. It is this need to finish a painting that induces his frenetic abandonment, but he paints in the eye of the storm. The painting, subject and artist become locked in a triangle that comes as near as possible to defeating time itself.

1 From an interview with Catherine Lampert in the catalogue of his only British retrospective, at the Hayward Gallery, London 1978.

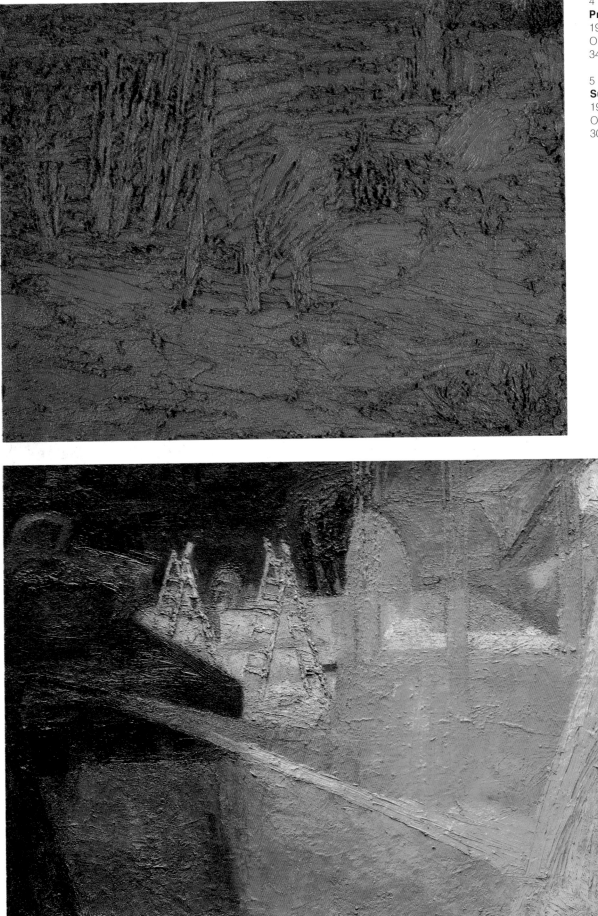

4
Primrose Hill
1954–55
Oil on board
34 × 46 (86.3 × 117)

5
Summer Building Site
1952
Oil on board
30 × 42 (76.2 × 106.7)

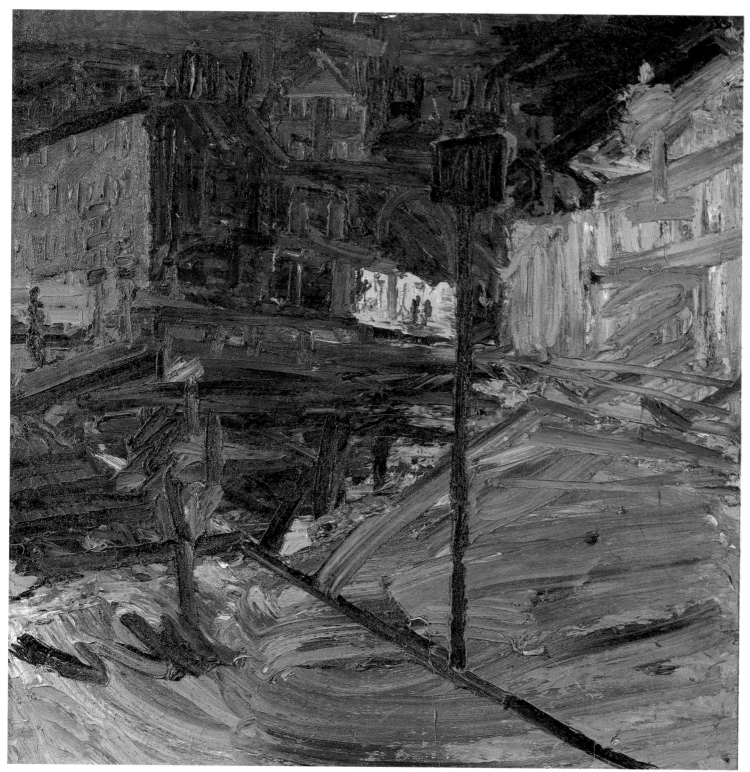

6
**Looking towards Mornington Crescent
Station – Night**
1972–73
Oil on board
50 × 50 (127 × 127)

7
E.O.W. III
1963
Oil on panel
27 × 22¾ (68.6 × 57.8)

8
**Railway Arches, Bethnal
Green II**
1958–59
Oil on board
48¼ × 59¼ × 3½
(122.5 × 150.5 × 8.5)

9
Rimbaud II
1976–77
Oil on board
42 × 42 (106.7 × 106.7)

10
To the Studio
1982–83
Oil on canvas
40½ × 48 (103 × 122)

11
Head of J.Y.M.
1986
Oil on canvas
22 × 20 (55.9 × 50.8)

12
J.Y.M. Seated
1986–87
Oil on canvas
28 × 26 (71.1 × 66)

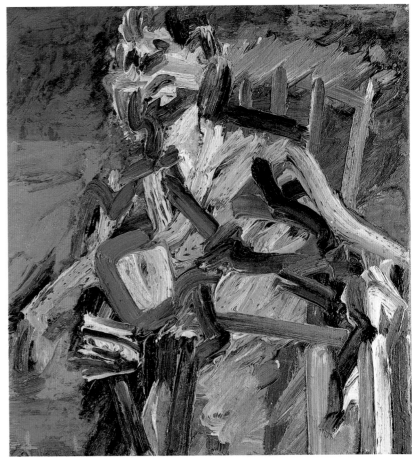

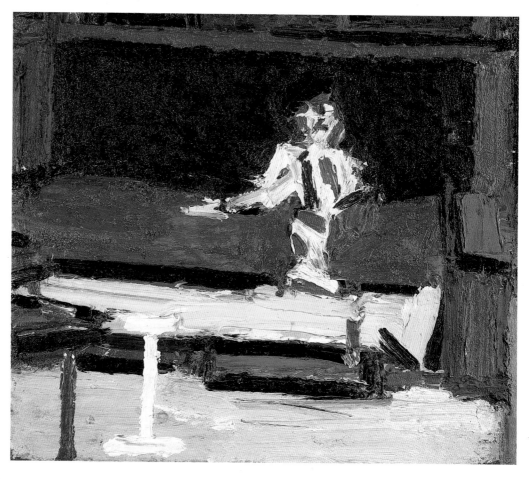

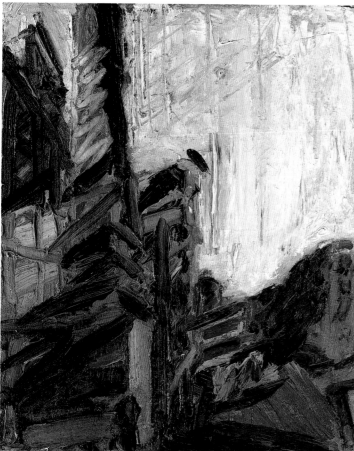

13
Figure on a Bed
1969
Oil on canvas
$23\frac{3}{4} \times 27\frac{3}{4}$ (60.3 × 70.5)

14
The Chimney – Mornington Crescent
1988
Oil on canvas
22 × 18 (55.9 × 45.7)

Patrick Caulfield

'In advertising you have to project or you don't make a sale', says Patrick Caulfield.[1] He doesn't expect the spectator to do all the work, yet ever since the sixties, even when he was considered a Pop artist, he has been in full flight from the obvious.

Caulfield is known for his brightly coloured, impersonal interiors. The characteristic thick black outlines have gradually disappeared in recent years, but, nevertheless, his constant theme appears to be the illustration of the superficial surface of modern life. *Foyer* (1973) must be a good example of today's machine-made purgatory, but there is a sense of deception. The more one looks at his work, the less one trusts to first impressions and the more one doubts that the pictures can be as straightforward as they look.

Caulfield paints slowly, finishing up to three paintings a year. There is a very down-to-earth element in his paintings. The title of *Fish and Sandwich* (1984) was chosen to emphasize this. It shows food on the sideboard of a Soho pub. The artist talks of the 'shock of the familiar'. He forces us to look again at what we think we know well. Then there is the colour. What is that blue doing in the middle of the picture? The South of France invades a gloomy London interior. He had escaped from the traditional British mud even before he arrived at the Royal College of Art in 1960. The example of the Douanier Rousseau is quoted, but Caulfield's career is littered with possible influences, almost as though he were hiding behind them. He is constantly running from his own signature. As soon as a style becomes identified with him, he drops it. This led him to adopt several styles in any one picture, as in the Tate's *After Lunch* (1975), where he inserts a Photo-realist window view of the Château de Chillon into a heavy line drawing of a pine and chrome restaurant.

Lunchtime (1985) appears to herald a perverse return to the bosom of traditional British painting. However, the confused background in *Glass of Whisky* (1987) depicts the darkest stained-oak panelling, and the delicate handling of the glass is accentuated by the surrounding thick, combed brown paint, denying a regression to earlier British values. Indeed, the painting recalls Caulfield's description of the South of France, as having 'a lot of texture'. His paintings have gained an objectivity and freshness from never subscribing wholeheartedly to one style or tradition, least of all his own. He has dodged movements and borrowed from them, but then he has settled down to the serious business of making a new and memorable image.

1 From interviews with Marco Livingstone in December 1980 for *Patrick Caulfield*, Tate Gallery, London 1981.

15
Foyer
1973
Acrylic on canvas
84 × 84 (213.4 × 213.4)

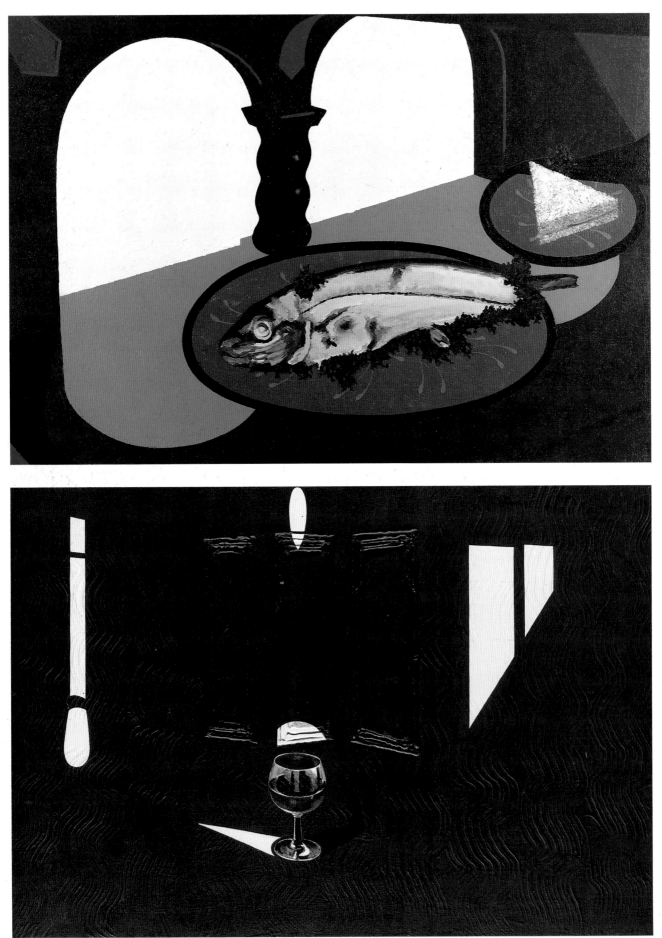

16
Fish and Sandwich
1984
Acrylic on canvas
30 × 44 (76.2 × 111.8)

17
Glass of Whisky
1987
Acrylic on canvas
30 × 44 (76.2 × 111.8)

18
Lunchtime
1985
Acrylic on canvas
81 × 96 (205.7 × 243.8)

Lucian Freud

The best thing would be to write down everything that happens from day to day. To keep a diary in order to understand. To neglect no nuances or little details, even if they seem unimportant, and above all to classify them. I must say how I see this table, the street, people, my packet of tobacco, since these are the things which have changed. I must fix the exact extent and nature of this change. Jean-Paul Sartre[1]

Lucian Freud uses realism like Sartre. They both employ a stark, sometimes brutal style as the most effective means of assaulting the way we see the world. Realism, for them, has been a necessary tool to strip back the layers of sentiment and illusion.

Freud exposes people's embarrassment at using their sight. Sartre's hero in *Nausea*, overcome by solitude, cannot even look at his own glass of beer. Both artist and writer exploit this reluctance to confront the world as it is. They show man and woman wriggling, contorting and sporting themselves in a mundane and reduced setting.

The *Blonde Girl on a Bed* (1987) lies on a meticulously painted bedspread. The artist has applied his remorseless gaze to the way the cream cloth is pulled and the light is absorbed by the rows of dark, crocheted knots. Similarly, Sartre scrutinized his hero's immediate surroundings: a café, its tables and a pool of spilt beer.

The use of materials in *Naked Man on a Bed* (1987) contrasts well with that in *Blonde Girl on a Bed*. The man's body echoes the crumpled cloths that the artist uses to wipe his brushes. They are invariably piled high in his studio and they fill the right-hand corner of this picture. The man lies face down on a smooth sheet, his legs curled in a distant approach to the embryonic position. In the other painting the woman shyly projects forward her pelvis. She may be vulnerable, but her limbs rise from the bed like a solid freestanding sculpture. She is a striking geometrical construction.

Girl Sitting (1987–88) has much in common with the right-hand figure in Francis Bacon's *Triptych – Studies of the Human Body* (1970), but the comparison underlines the very different routes the two painters have chosen. Bacon creates his own structure on which to disrupt the human figure. Freud places his model on a bed in his studio: rather than creating a reduced language of his own, he has turned to realism, believing it to be the most effective way of forcing us to use our eyes.

1 The opening lines of *Nausea*, trans. Robert Baldick, Penguin, Harmondsworth 1963.

19
Night Interior
1969–70
Oil on canvas
22 × 22 (56 × 56)

20
Dead Bird
1943
Ink, watercolour and gouache on paper
$14\frac{1}{2} \times 20\frac{1}{2}$ (36.9 × 52.1)

21
Hand Puppet
1944
Oil on wood
$7\frac{1}{4} \times 9\frac{5}{8}$ (19 × 24.5)

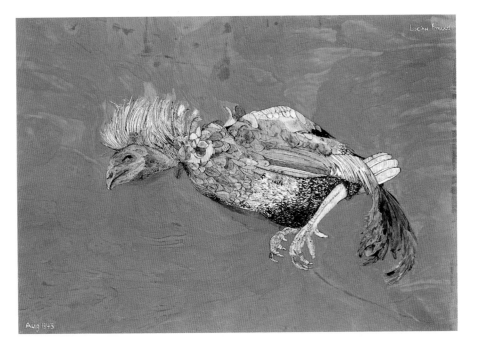

22
The Spotted Jacket
1942
Watercolour and pen
$10\frac{1}{4} \times 7\frac{1}{4}$ (26 × 18.3)

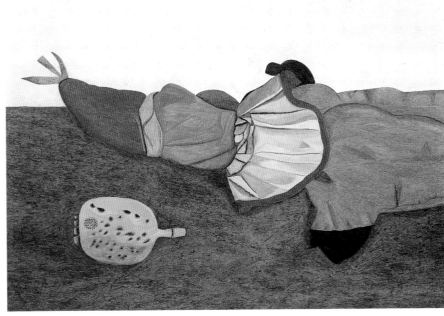

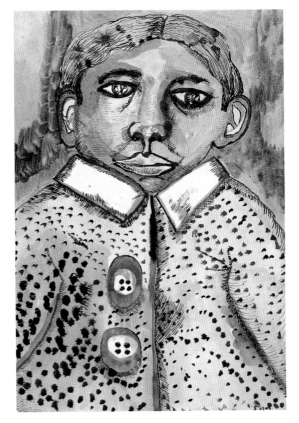

23
Dead Monkey
1944
Ink on paper
8 × 13 (20.3 × 33)

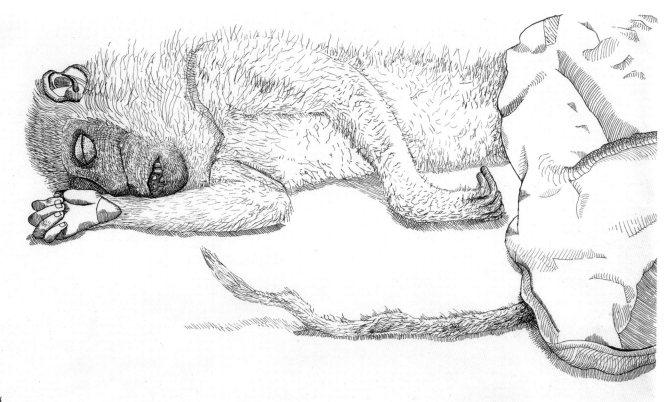

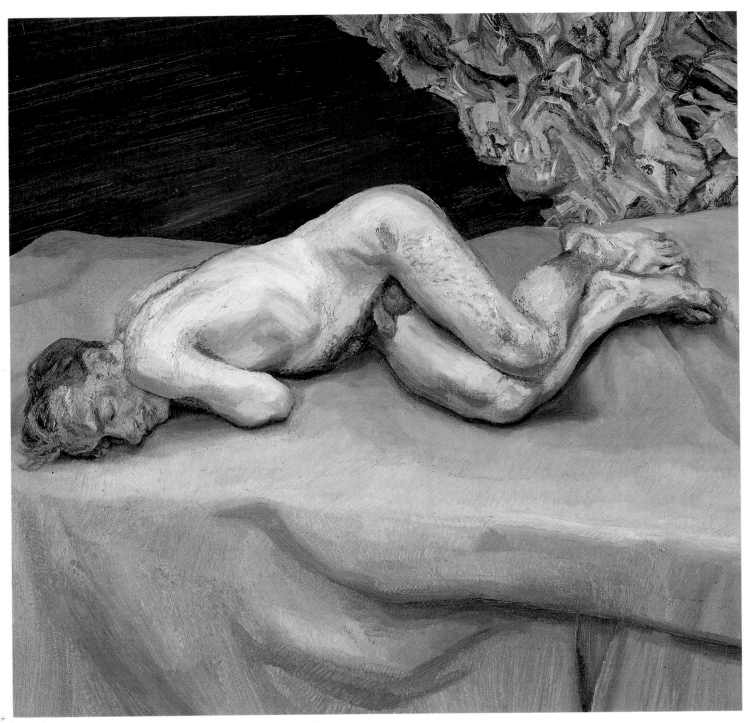

24
Naked Man on a Bed
1987
Oil on canvas
$22\frac{1}{4} \times 24$ (56.5 × 61)

25
Woman in Grey Sweater
1988
Oil on canvas
$21\frac{7}{8} \times 17\frac{7}{8}$ (55.6 × 45.3)

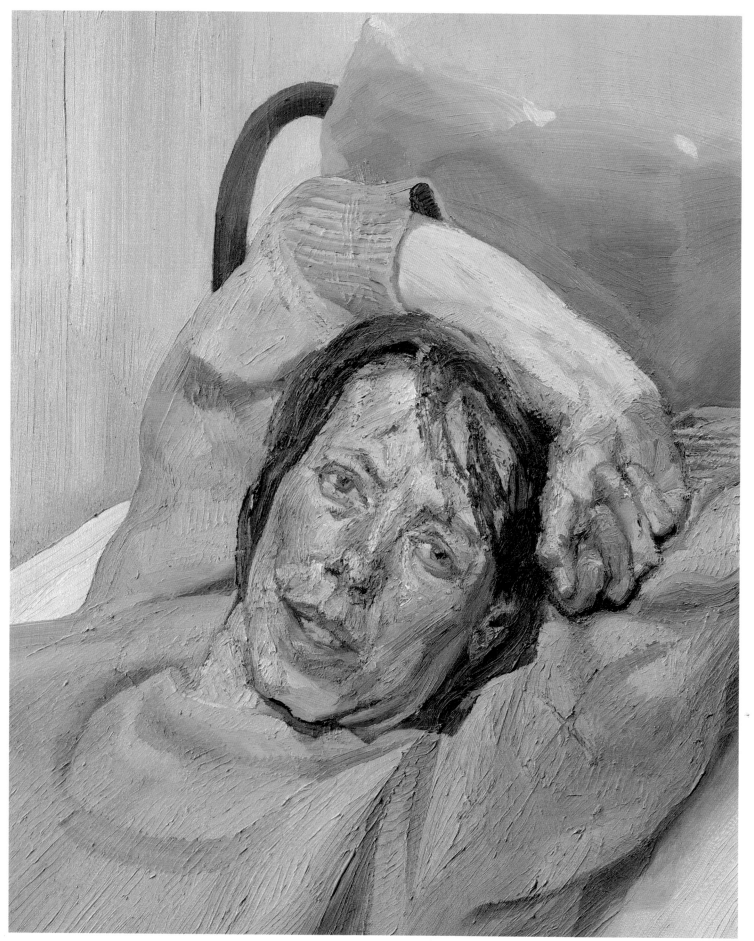

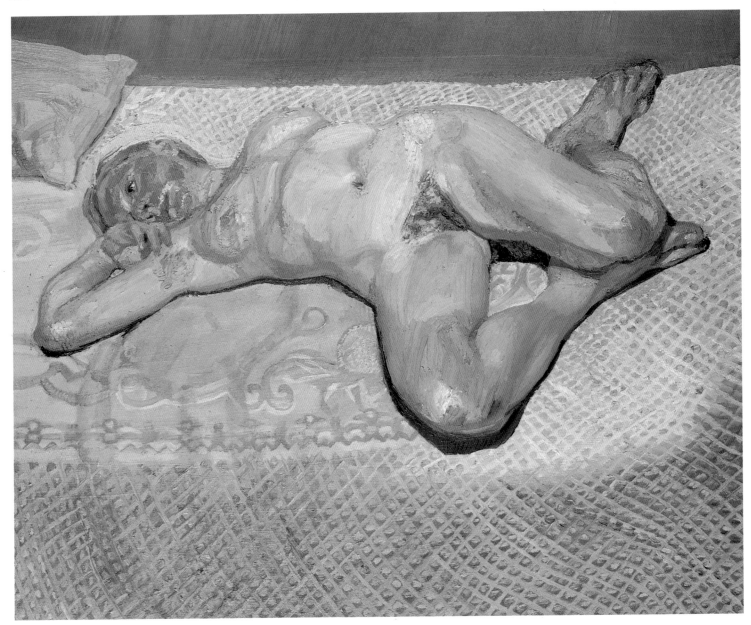

26
Blonde Girl on a Bed
1987
Oil on canvas
$16\frac{1}{8} \times 20\frac{1}{8}$ (41 × 51)

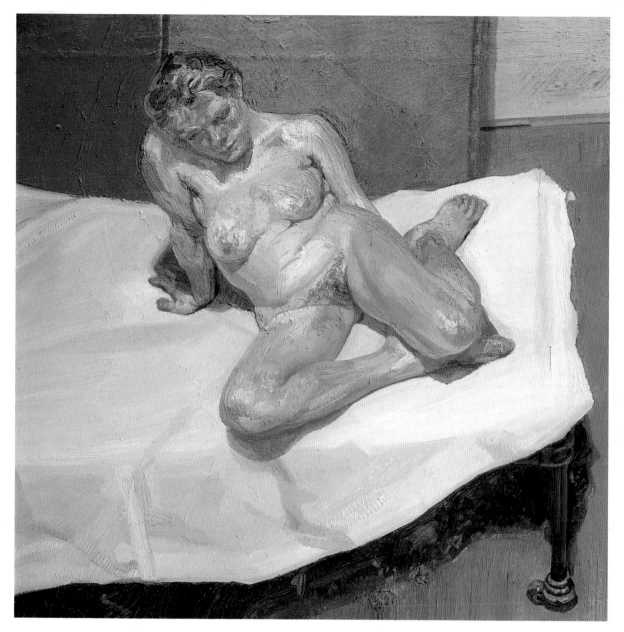

27
Girl Sitting
1987–88
Oil on canvas
$21\frac{1}{2} \times 21\frac{7}{8}$ (54.6 × 55.5)

Howard Hodgkin

'A painter more naturally and effortlessly original, more entirely himself than anyone else alive', concluded Sir Lawrence Gowing in his introduction to Hodgkin's 1981 show at Knoedler's, New York. Original yes! Effortless no! He has laboriously forged a language of his own over many years. His first pictorial steps resemble those of a young giraffe. There were passages of that rare and unrepeatable, awkward power of youth, but it was not until the seventies that he learned to manipulate his own vocabulary and grammar to full poetic effect.

The paintings from the late fifties and sixties may suffer from comparison with the cohesion of the later work, but they supply a direct insight into Hodgkin's intentions. He was twenty-six when he completed *114 Sinclair Road* (1957–58) and it marked a return to earlier concerns that had culminated in *Memoirs* (1949, collection of the artist). It was a bold decision. He was dispatching himself to no man's land, apparently waving the red flag at every accepted idea of modern painting. Yet as the sixties progressed he showed he was fully aware of the ideas of the time. His work even displayed similarities to Pop, Op and Minimalism, while blatantly breaking their rules.

Today it is hard to imagine that *The Room* (1960) belongs to Hodgkin's *oeuvre*. The majority of the surface is given over to a white, highly textured surface that would satisfy many a Minimalist. As he had already demonstrated in *114 Sinclair Road*, he is making the viewer strive to reconstruct a specific and personal event in the artist's memory. The pursuit of knowledge, even though it may be elusive, is essential. It ensures reappraisal. It is yet another device to force the eye to re-read the painting.

Hodgkin confronts accepted ideas about painting. He exploits abstraction without fully yielding to it. He starts from the essential premise that a painting is an object. It is not a window. Illusion is the only way to break the surface. Yet most of the individual components of his paintings are abstract, brightly coloured dots, thick paint-laden stripes and swirls. As his art has developed he has relied less and less on the figurative gesture, though the locating of the human presence in paint is of primary importance.

Hodgkin's reputation as an isolationist stems from a refusal to accept or react against the generation before him. Instead he has looked back to the birth of modern art. The crucial point of departure is Cubism. He has sought new ways to realize Cubist aims, but has done so in the spirit of Vuillard, Bonnard and Matisse. This does not mean that he has ignored all subsequent art: far from it, he can be seen travelling on paths parallel to those of Barnett Newman, R.B. Kitaj and even Sean Scully. The highly personal nature of Hodgkin's art ensures that any shared aims are disguised under a generous cloak of his own information.

Hodgkin's paintings are about human beings. In an age used to standard-size canvases, he has painted small, intimate and unashamedly decorative pictures. His pursuit of figures in interiors has led John Russell to place him in a French tradition dating back to the seventeenth-century Le' Valentin.[1] Certainly Hodgkin has come close to making the double portrait his signature.

The double portraits in the Collection span the crucial period of Hodgkin's development. *Mr and Mrs Robyn Denny* (1960) confront us full on. There are tricks. The background pattern is not as straightforward as it at first looks, nor are Denny's red eyes as flatly painted as they appear, but by 1974 when *Dick and Betsy Smith* was finished there is not a trace of such crude confrontation. The traditional representation of the sitters, again a painter and his wife, has all but disappeared. The success of the picture now totally depends on the marks of paint and the way they interact with each other. The focus is on the oasis of colour within the blue-spotted boundary. The painted blue frame contains the composition but there is also a polite invitation into the picture. A line of red and black squares extends from the top of the painting on to the frame. The brush strokes and dabs are extravagant in the lush centre. It is not an accident that this most fastidious of painters lets a drop of blue paint fall and congeal on a bright patch of green. There are several similar messages. The language was formed.

The eighties have seen a burst of fluency. In *After Dinner at Smith Square* (1980–81), Hodgkin is prepared to introduce dull colours to highlight the bright blue cross. *Clean Sheets* (1982–84) and *Menswear* (1980–85) persist with camouflage greens, but some surprise always slips through the netting. His attacks on our complacent way of looking at things gain in confidence and variety every year. Some doubt that he can take his art further. An artist who has developed so steadily over thirty years is not going to stop now.

1 *Private View* by Robertson, Russell and Snowdon, Nelson, London 1965.

28
Mr and Mrs Robyn Denny
1960
Oil on canvas
36 × 50 (91.5 × 127)

29
114 Sinclair Road
1957–58
Oil on canvas
35 × 44 (88.9 × 111.7)

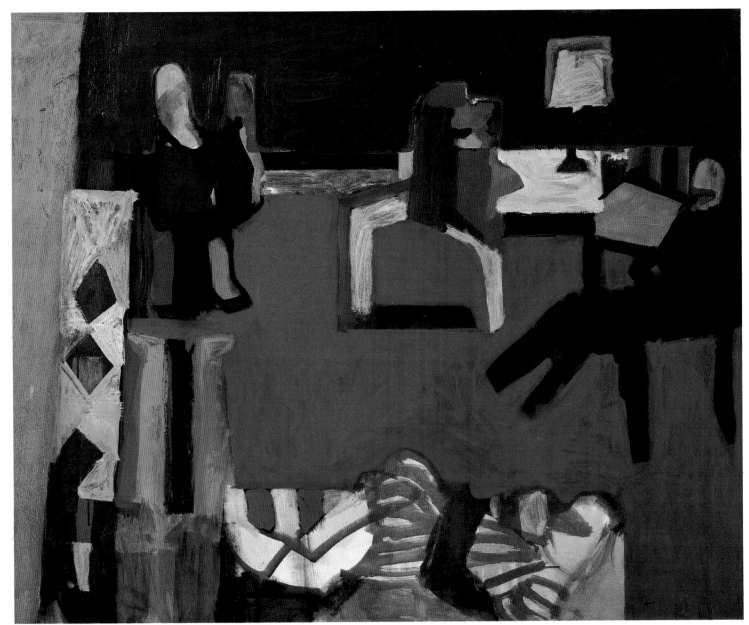

30
Girl in Bed
1965
Oil on canvas
$27\frac{7}{8} \times 36$ (71 × 91.4)

31
Dick and Betsy Smith
1971–74
Oil on wood
$23\frac{1}{4} \times 29$ (59.1 × 73.3)

32
Portrait of Mr and Mrs Kasmin
1964–66
Oil on canvas
$41\frac{1}{2} \times 50$ (106 × 127)

33
After Dinner at Smith Square
1980–81
Oil on board
31 × 41 (78.7 × 104.1)

34
Blue Evening
1972
Oil on board
26 × 29 (66 × 73.5)

35
Family Group
1973
Oil on canvas
36 × 42 (91.5 × 106.7)

36
Clean Sheets
1982–84
Oil on wood
22 × 36 (55.8 × 91.4)

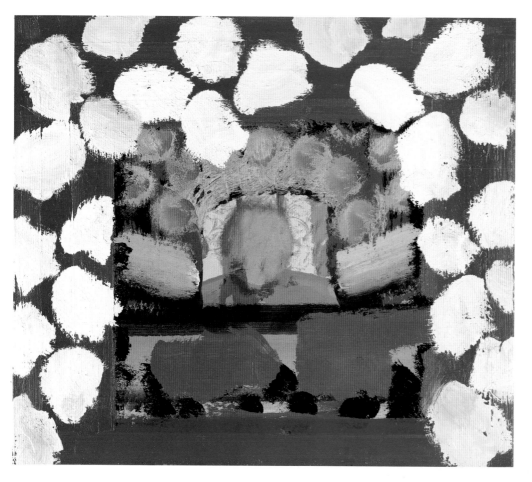

37
Paul Levy
1976–80
Oil on canvas
$20\frac{7}{8} \times 24$ (53 × 61)

38
A Henry Moore at the Bottom of the Garden
1975–77
Oil on canvas
$40\frac{1}{2} \times 40\frac{1}{2}$ (102.9 × 102.9)

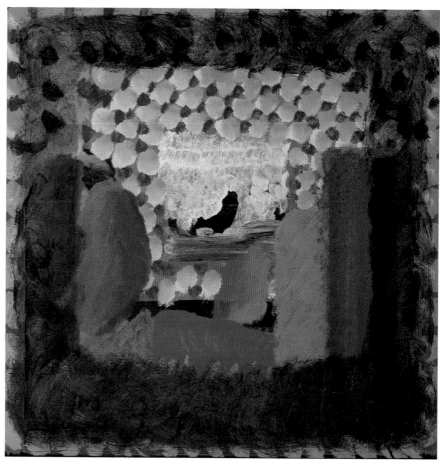

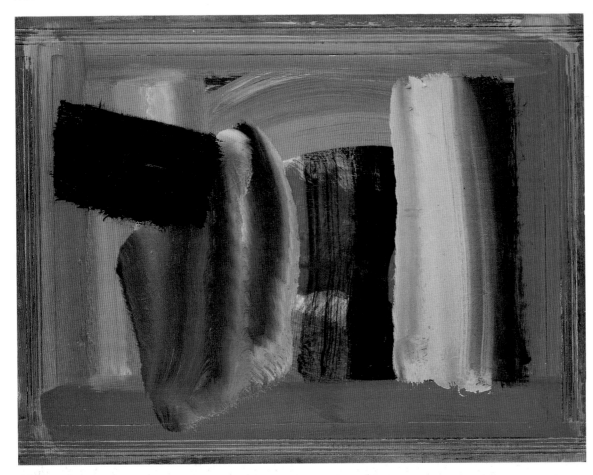

39
Haven't we met?
1985–88
Oil on wood
$19\frac{1}{4} \times 25\frac{1}{4}$ (48.9 × 64.1)

40
Menswear
1980–85
Oil on wood
$32\frac{3}{4} \times 42\frac{1}{2}$ (83 × 108)

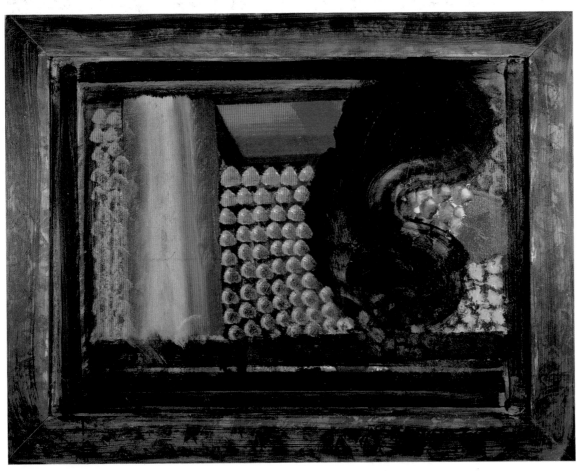

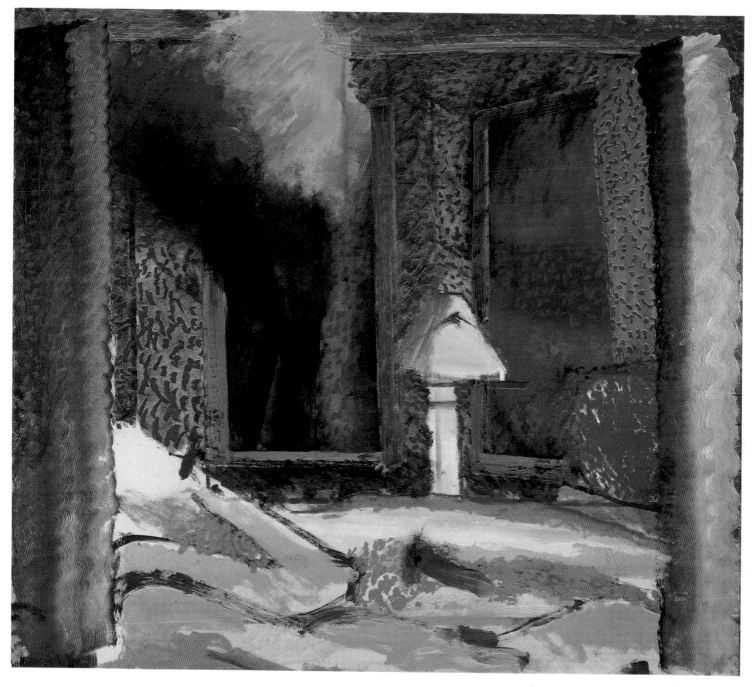

41
Interior with Figures
1977–84
Oil on wood
54 × 60 (137.2 × 152.5)

R.B. Kitaj

Kitaj is one of those rare people prepared to take the weight of the world upon their shoulders. At the moment he is threatened because the State of Israel is threatened. His paintings and writings reflect this.

The Corridor (After Sassetta) (1988) originally had the subtitle *Two Genocides*. The mood has changed radically from the Tate Gallery's *Cecil Court, London WC2 (The Refugees)* (1983–84), in which literati find refuge in a similar alley, one lined with bookshops. Bare walls have replaced the shops and other signs of human existence. Two uniformed men scurry to their burrows, determined not to witness the end of civilization.

The two genocides are taken from Sassetta's *St Antony Beaten by Devils* (1423–26). The 'Big Brother' image on the poster at the end of the passage oversees the operation like the central, snake-bedecked figure in the predella, which itself appears to have been vandalized. The faces and genitals of the devils are obliterated in passages of red and gold paint, though a face does emerge from the baboon bottom of the right-hand demon. Kitaj has emphasized this to form a triangle of yellow violence out of genocide and genitalia. 'Whether I'm doing genocidal death any "justice"', he writes, 'I don't know.'

Kitaj's writings have assumed a new role. For many years he has been supplying 'prefaces' for some of his paintings, his own interpretations ('exegeses') of works he had often done several years before. In August 1987 he started, for the first time, to write about a picture which he hadn't even begun, *Germania (Vienna)* (1987). He continued to write about the painting until it was finished in November. This constant self-examination is being made public in *Autobiography of My Pictures*, a series of his own writings on his paintings.

Kitaj, with his combination of honest self-appraisal and an ever-enquiring imagination, would make a brilliant diarist. In a sense he has become one. He is increasingly reclusive. Yet through the written word, the telephone and meeting people for lunch, he has frequent contact with many fine minds. He observes the world with a frightening clarity.

Kitaj is not a believer, but has adopted several of the thought patterns of Judaism and, strangely, these link with the mainstream of twentieth-century art. In *The Neo-Cubist* (1976–87), as well as showing David Hockney tied within the restraints of Cubism's legacy, he offers a road forward. He is an expansive artist. He may not have found an 'ultimate revelation', but he stares hard at the world. His paintings have long been composed of the multitude of glimpses that makes up this vision. His writings have always interpreted this, but now they also explain the process. Man seems more threatened then ever.

42
The Neo-Cubist
1976–87
Oil on canvas
70 × 52 (177.8 × 132.1)

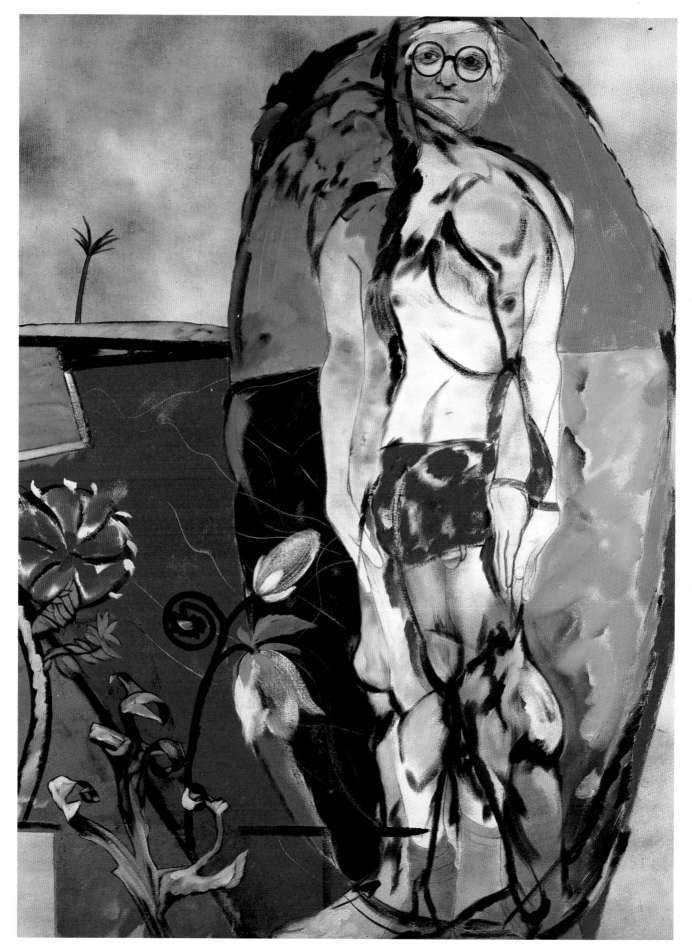

43
The Sniper
1987
Oil on canvas
120 × 36 (304.9 × 91.4)

44
The Drivist
1985–87
Oil on canvas
72½ × 36 (183.5 × 91.4)

45
Germania (Vienna)
1987
Oil on canvas
$47\frac{1}{4} \times 60$ (120 × 152.4)

46
The Corridor (After Sassetta)
1988
Oil on canvas
$48\frac{1}{4} \times 60\frac{1}{4}$ (122.6 × 153)

Leon Kossoff

Leon Kossoff has spent his life exploring, through drawings and paintings, his relationship with the city of London. Through his paintings of his father and the friends who sit for him, he has extended his own world, his anxiety and joy, into his work which emerges as a very particular vision of everyday life.

Leon Kossoff was born in 1926 in a now-demolished building on the City Road in the City of London, where his Russian Jewish parents had settled a few years earlier. His father had a small bakery in the East End. His sitters are people within his immediate circle. They appear very solid but there is a hint of displacement, that they have been picked up and accidentally dropped in a 'front room' in Brick Lane or the artist's studio. In selecting his cityscapes he never wanders from the north-west or north-east of London. Even the people in the street, underground stations, swimming baths or other crowd scenes partly originate from his own private world. 'Although made from numerous drawings done in the street over long periods of time,' he wrote to his dealer in 1987, 'at the final moment each person becomes someone particular that I know.'

Kossoff's choice of subject-matter has expanded over the years. His father, a woman called Seedo and building sites were his earliest. In 1964 he began drawing in Willesden. In 1967 he started drawing the children's swimming pool in Kilburn. A year later he was drawing the underground station there, though the first painting of Kilburn Underground didn't emerge until 1976. He has drawn extensively in the National Gallery. The last few years have seen a lighter mood and brighter colours, and he has embarked on two new subjects that have intrigued him for some time, Christ Church Spitalfields and trains. Railways, the arteries of the city, have played an important role in his vision of London. He painted *Railway, Bethnal Green* (not in the Collection) as early as 1960, but moving trains have introduced an unexpected challenge into the work.

People pouring out of the underground, pedalling bicyclists and passing cars have long been accommodated in Kossoff's drawings and paintings, but in *Here Comes the Diesel, Early Summer 1987*, and others of the series, the speed of two trains becomes a major factor in the success of the paintings. One can almost hear the pattern of the noise changing, the individual repetitive rattle of each of the trains giving way to the rush of wind and whistle of their passing. He has clearly admitted the importance of time since the swimming pool paintings. The two poplars behind the trains might remind the viewer of Monet, who also displayed systematic dedication to his subject-matter. The yellow-capped diesel enters the canvas diagonally amidst a wild haze of paint strands, yet there is no confusion. The countless drawings and reworkings can be no more than rehearsals, for he is endeavouring to capture one single moment.

Painting by its nature has to aspire to a certain timelessness. Kossoff achieves this by portraying scenes that virtually everyone must have seen. In *A Street in Willesden* (1985), a man sits on a bench and watches the world pass by. Into his immediate vision comes a young couple, hand in hand, with a dog waddling in front, but the man avoids looking at them and instead looks up into the skies as though lost in his own thoughts. Behind him pans out a tree-lined avenue. A woman pushes her pram across a patch of green. Another couple walk away along the pavement. Another man sits on another bench. Man's isolation, his determination to walk his own path and enjoy his own thoughts, is a sight to be found on every street corner.

49, 50
Double Self-Portrait
1969
Oil on board
Each panel: 30 × 30 (76.2 × 76.2)

51
Nude on a Red Bed
1972
Oil on board
48 × 72 (122 × 183)

47
Woman ill in Bed
1957
Oil on canvas
36 × 48 (91.4 × 121.9)

48
Portrait of Father III
1972
Oil on board
60 × 48 (152.5 × 122)

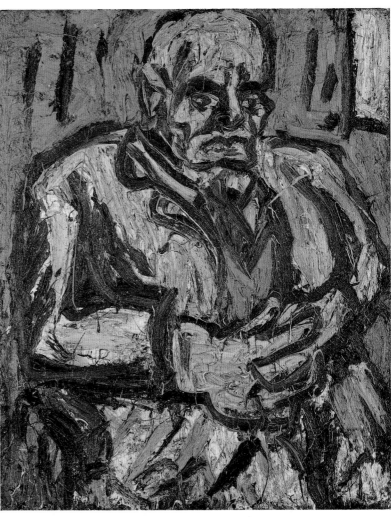

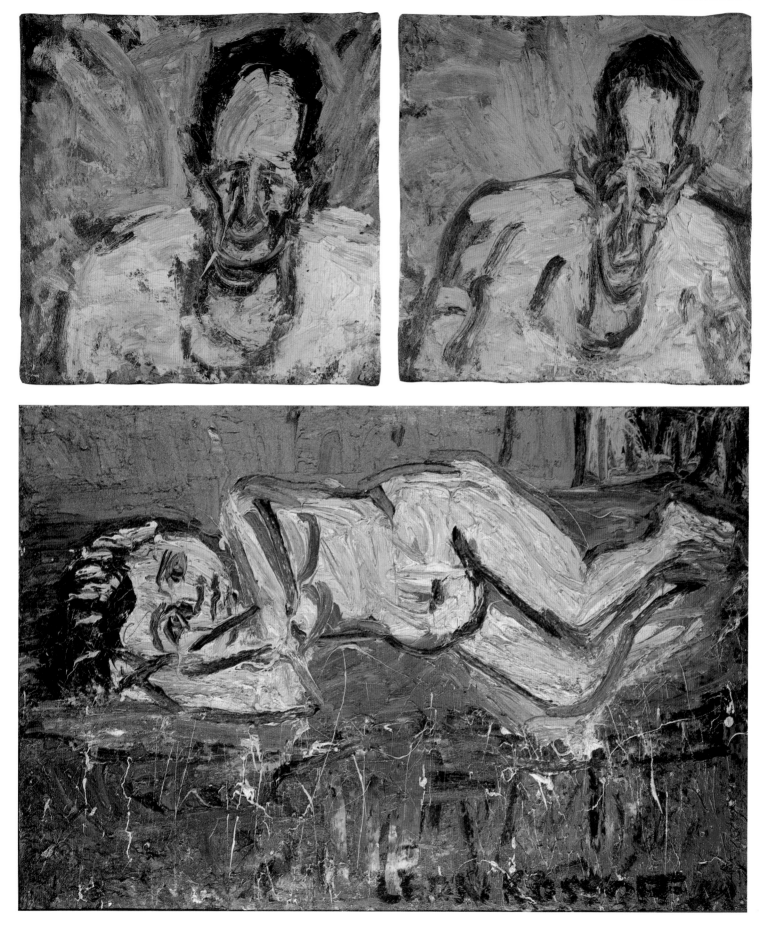

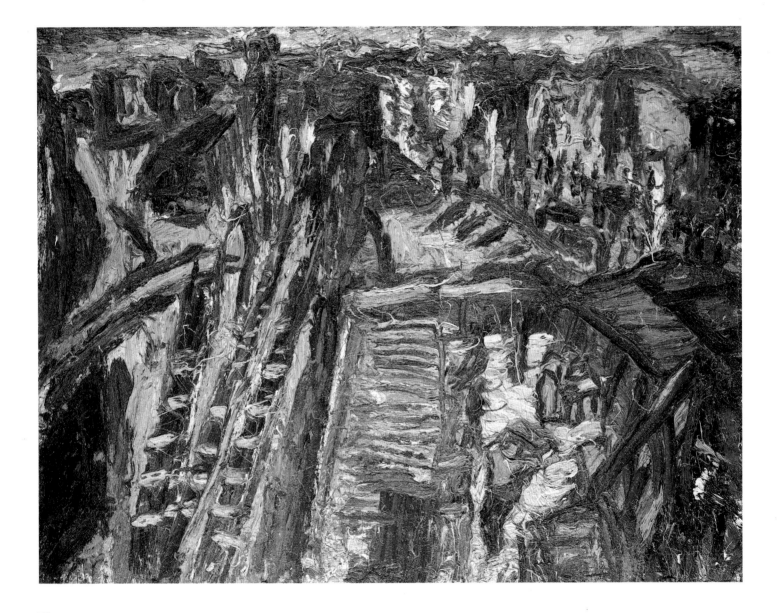

52
**Dalston Junction Ridley Road Street Market,
Stormy Morning**
1973
Oil on board
55 × 72 (139.7 × 183)

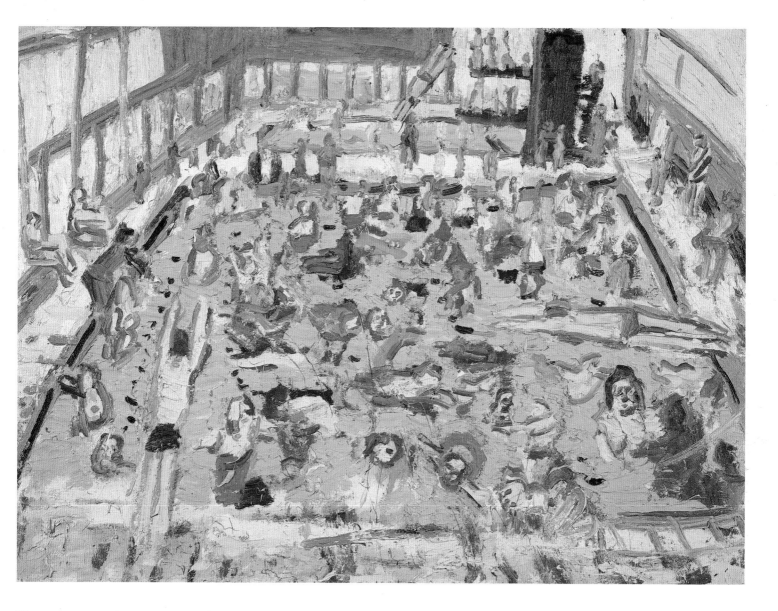

53
Children's Swimming Pool, 11 o'clock
Saturday Morning, August 1969
1969
Oil on board
60 × 81 (152.5 × 205)

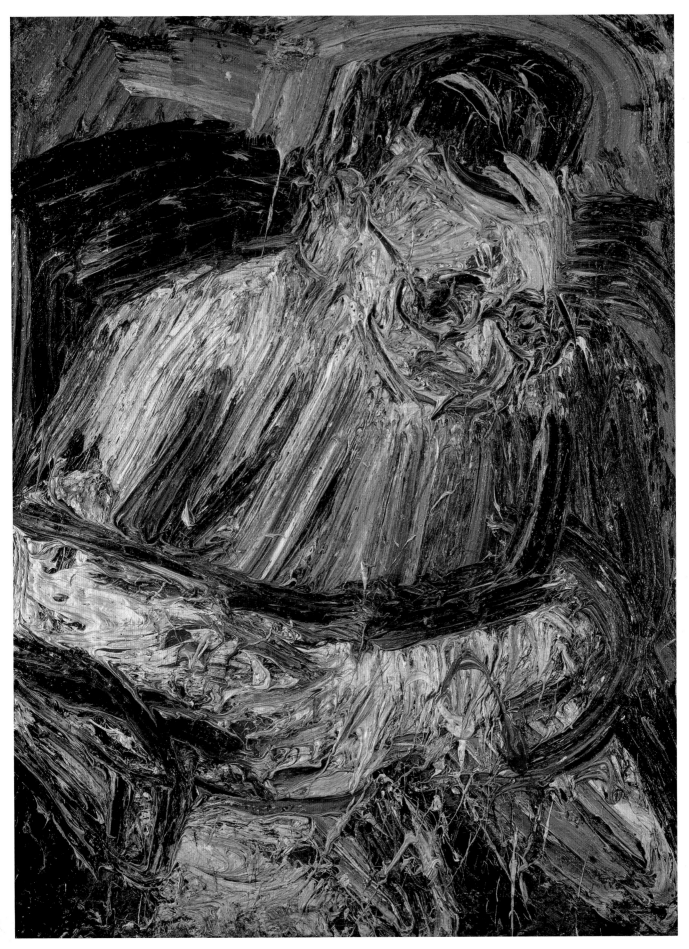

54
Portrait of Philip Kossoff I
1962
Oil on panel
63 × 48 (160 × 122)

55
Two Seated Figures I
1980
Oil on board
48 × 60 (122 × 152.4)

56
Breakfast
1981
Oil on board
48 × 72 (122 × 183)

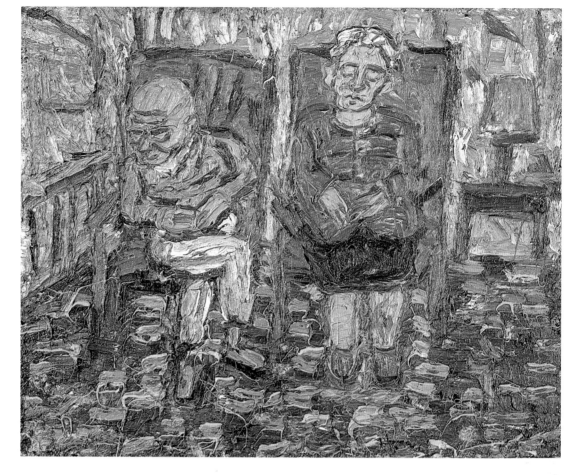

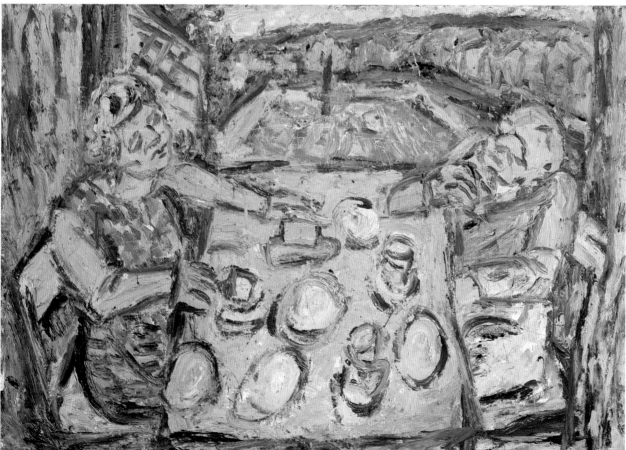

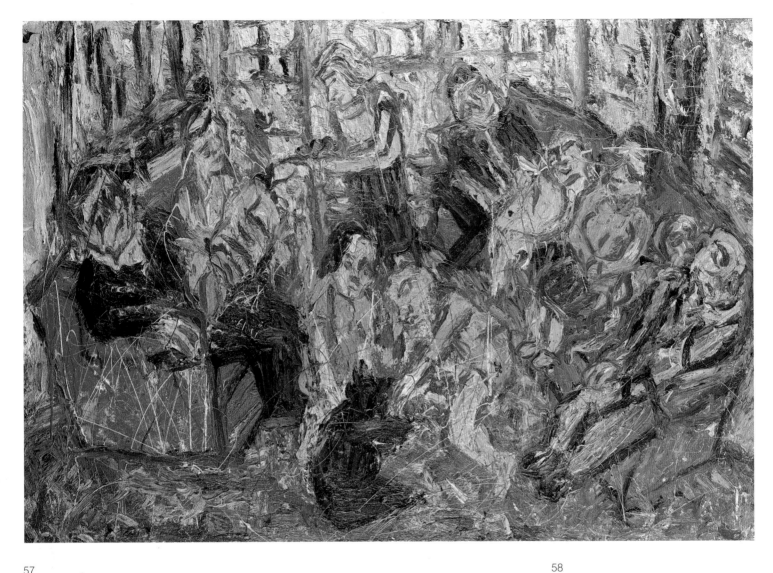

57
Family Party, January 1983
1983
Oil on board
$66 \times 98\frac{1}{4}$ (167.6 × 249.5)

58
**Inside Kilburn Underground,
Summer 1983**
1983
Oil on board
$54\frac{1}{4} \times 66\frac{1}{4}$ (138 × 168.3)

59
School Building, Willesden, Spring 1981
1981
Oil on board
$53\frac{1}{2} \times 65\frac{1}{2}$ (136 × 166.4)

60
School Building, Willesden, May 1983
1983
Oil on board
$54\frac{1}{4} \times 72$ (138 × 183)

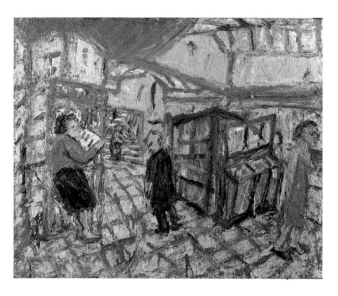

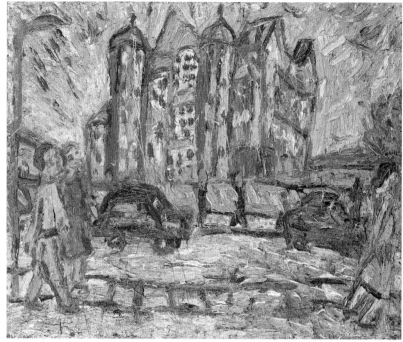

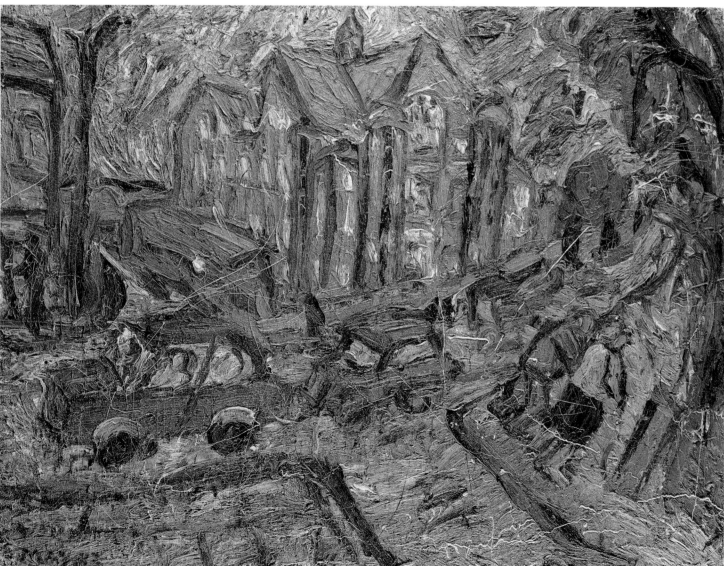

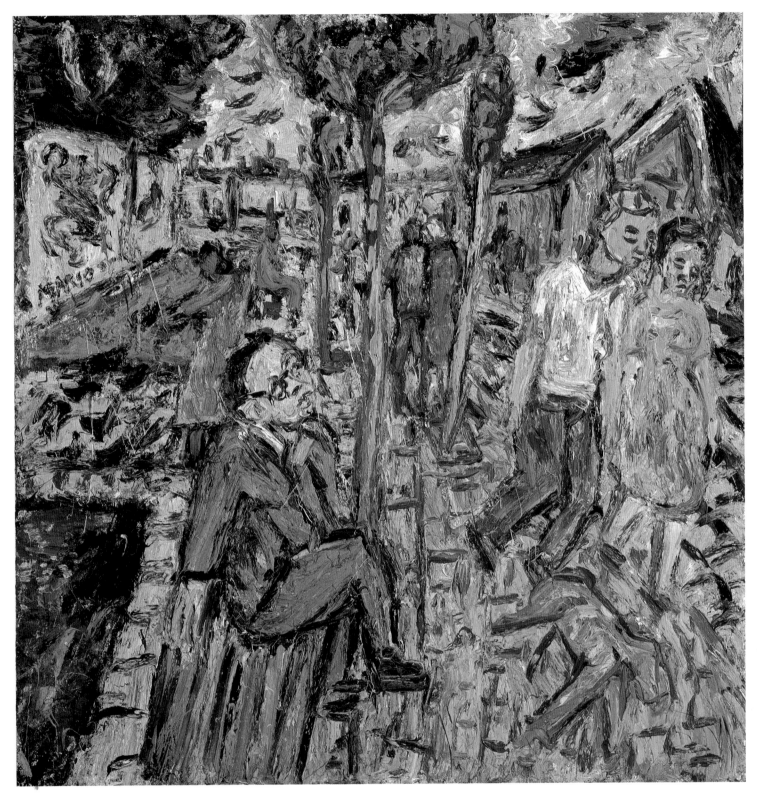

61
A Street in Willesden
1985
Oil on board
$83\frac{1}{2} \times 81\frac{1}{2}$ (212 × 207)

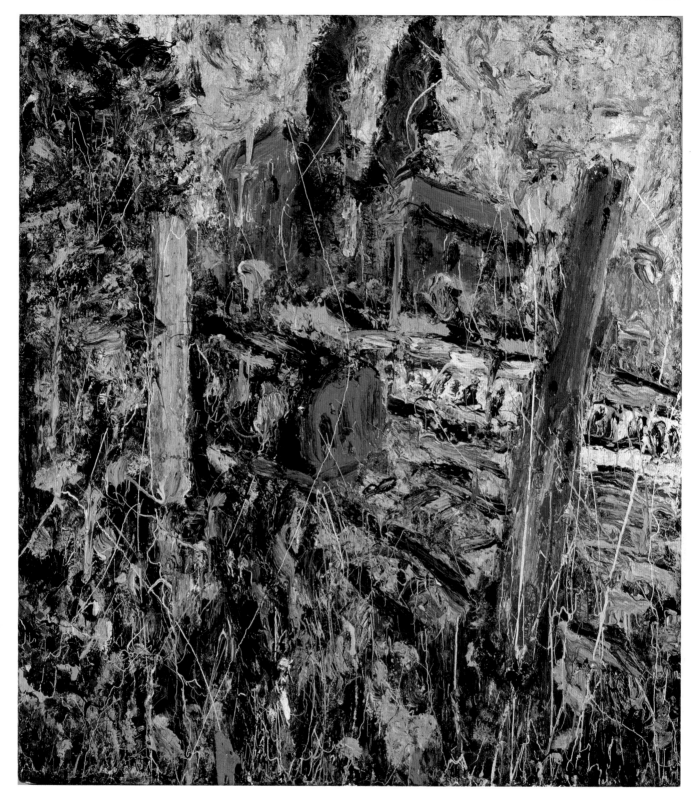

62
Here Comes the Diesel, Early Summer 1987
1987
Oil on board
54 × 48 (137 × 122)

Lisa Milroy

I would stop by the table, where the kitchen-maid had shelled them, to inspect the platoons of peas, drawn up in ranks and numbered, like little green marbles, ready for a game; but what most enraptured me were the asparagus, tinged with ultramarine and pink which shaded off from their heads, finely stippled in mauve and azure, through a series of imperceptible gradations to their white feet – still stained a little by the soil of their garden-bed – with an iridescence that was not of this world. Marcel Proust[1]

Lisa Milroy paints objects against a white background. They are often regimented; there is always an implication of order, even if it is not at first apparent. Any hint of sentimentality is avoided. Her admiration for Proust reflects her interest in descriptions of a highly particular nature. Her pairs of shoes, fans and sailor caps make use of repetition to abstract the image, but for all the apparent harshness of her gaze, there is invariably a touch of luxuriance in the paint.

In *Sailors' Caps* (1985), Milroy removes the hats from their normal setting. She edits the information so that she can concentrate on the qualities for which she chose the hats. There is a rhythm developed between the five rows of five caps as the cloth tops flop into a host of different positions. The white crests of waves roll up the canvas. Like John Murphy she uses the surface of the painting to reinforce the imagery. The brush strokes are broad and loose, so that one has the separate experience of them in addition to the way they cohere to depict an image.

Milroy's objects capitalize on the fact that they are painted. Previously, repetition has been the province of the Minimalist sculptor or Pop artist. She has absorbed the technique into the mainstream tradition of painting. Proust evokes Manet's singular portrayal of *Asparagus* (1880). George Bataille's words on the first modernist could equally provide a starting point to Milroy's work: 'Manet's splendid still lifes are quite unlike the decorative *hors-d'oeuvre* of the past. They are pictures in their own right, since Manet, from the very start, had put the image of man on the same footing as that of roses or buns.'[2]

1 *Remembrance of Things Past*, trans. C.K. Scott Moncrieff and Terence Kilmartin, Chatto & Windus, London 1981.
2 George Bataille, *Manet*, Skira, New York 1955.

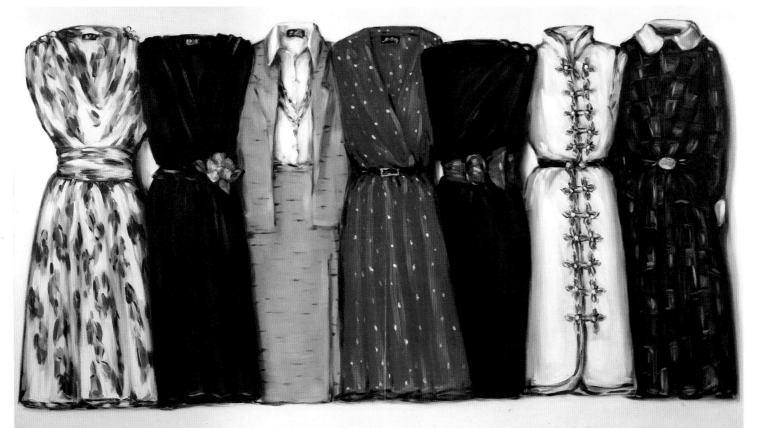

63
Dresses
1985
Oil on canvas
$81\frac{3}{4} \times 140\frac{1}{4}$ (207.6 × 356.2)

64
Regiment
1985
Oil on canvas
72 × 80 (183 × 203)

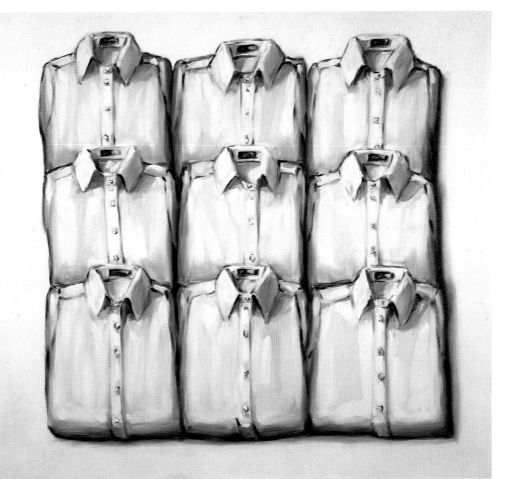

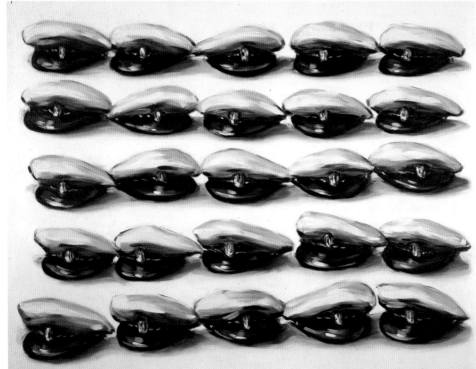

65
Japanese Prints
1986
Oil on canvas
$90 \times 68\frac{1}{2}$ (228.6 × 174)

66
Sailors' Caps
1985
Oil on canvas
$75\frac{1}{2} \times 95\frac{3}{4}$ (191 × 243.2)

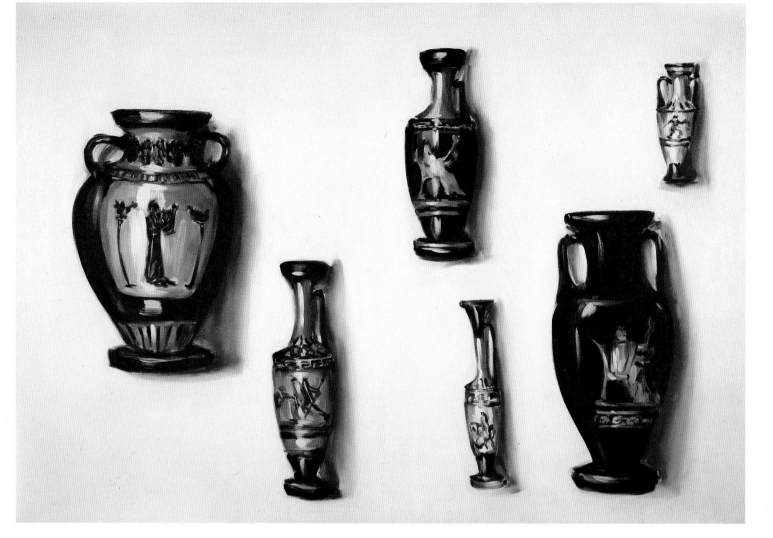

67
Greek Vases
1985
Oil on canvas
68¾ × 100¼ (174.6 × 254.6)

68
Roman Coins
1985
Oil on canvas
69½ × 79¾ (176.5 × 202.5)

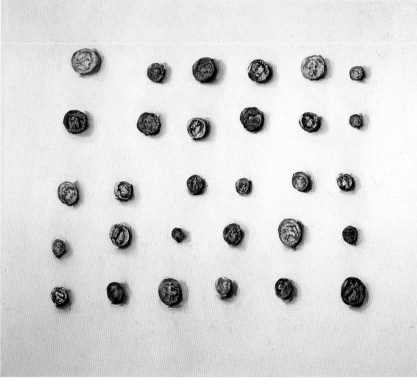

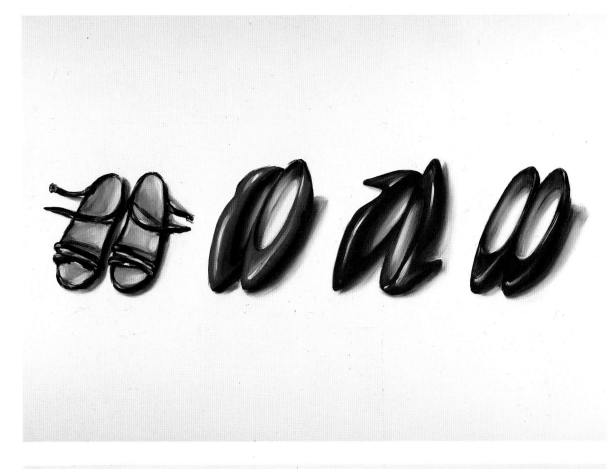

69
Row of Shoes
1985
Oil on canvas
$68 \times 95\frac{1}{4}$ (172.7 × 242)

70
Shoes
1985
Oil on canvas
$69\frac{1}{2} \times 89$ (176.5 × 226)

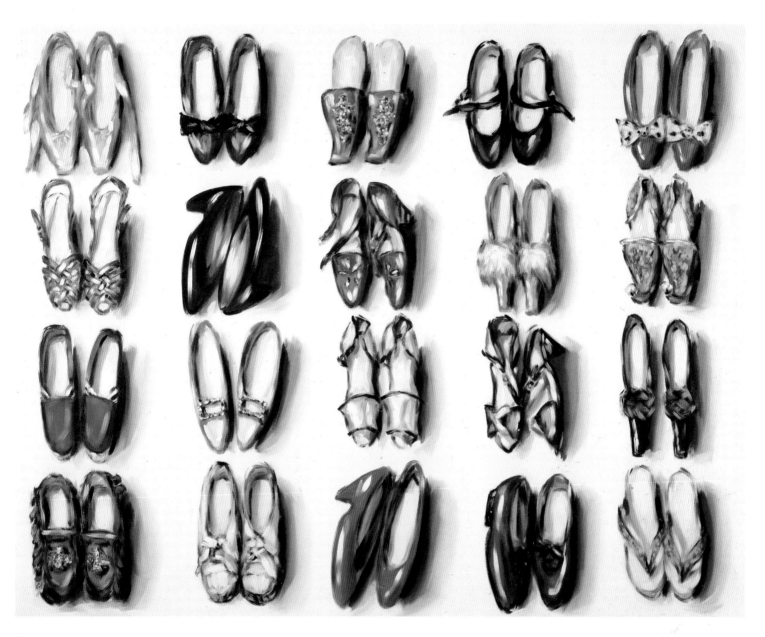

71
Shoes
1986
Oil on canvas
80 × 120 (203.2 × 304.8)

72
Fans
1986
Oil on canvas
$75\frac{3}{4} \times 95\frac{1}{2}$ (192.4 × 242.5)

73
Silverware
1987
Oil on canvas
85 × 90 (216 × 228.6)

74
Tyres
1987
Oil on canvas
80 × 112 (203.2 × 284.5)

75
Pulleys, Handles, Castors, Locks, and Hinges
1988
Oil on canvas
80 × 112 (203.2 × 284.5)

Malcolm Morley

Malcolm Morley is an important if elusive link between American and European painting. He has taken his followers through a helter-skelter ride of styles, which he has often mastered but rarely fully adopted. A refusal to be categorized and a highly developed sense of irony and self-criticism have led him to dramatic changes in direction.

Morley coined the phrase 'Super Realism'. He took Photo-realism to the heights of *SS Amsterdam in Front of Rotterdam* (1966) and *Vermeer, Portrait of the Artist in his Studio* (1968), but even then there was an element of pastiche. Unlike most Photo-realists he has never used a slide projector. Having laboriously created the illusion of the boat and the Dutch masterpiece, he mocks it by including the white border of the postcard he has copied. In *Race Track* (1970, Ludwig Collection, Aachen) he went much further, and meticulously painted the segregated white and black crowds either side of the racing horses. Finally, after months of work, as if in aesthetic protest as well as political, he put a large red cross over the whole image.

It takes philosophical as well as artistic presumption to remake Raphael's *School of Athens* (1510–11). Morley began his version of the painting in 1972 as he gave a college tutorial dressed as Pythagoras, though in the end he chose to portray himself neither as the mathematician nor in the place of Raphael, but as Diogenes, the Cynic, who lies in rags on the steps. The painting might have proved a tame charade, if an accident hadn't occurred. In filling in the prepared grid for this painting, a device he had used since the early ship paintings, he made the mistake of slipping one square to the right. The philosophers now appear like a row of classical sculptures in the process of decapitation. The confusion of exchanged heads, half-digested ideas and disrupted architecture created fertile ground in which the artist could develop.

The Abstract Expressionists were an essential part of America's attraction for Morley, which led him to visit in 1957 and to settle there permanently the following year. In his flight from Photo-realism he once again looked to Expressionism. In *Untitled Souvenirs, Europe* (1973), *SS France* (1974) and other works from that period, he returned to the use of oils rather than acrylics and unleashed a violence in the paint, a savagery in form that was taken up by Berlin's *Heftige Malerei* (Violent Painting), and an assault on the surface to be echoed by Kiefer, Schnabel and Cucchi. He literally breaks the canvas into three parts in *Camels and Goats* (1980), and the imagery in *Farewell to Crete* (1984) shatters as if made of ancient pottery, but at the same time the artist makes other, perfectly cohesive compositions. He is restless and anxious; consistency holds little allure.

76
SS Amsterdam in Front of Rotterdam
1966
Acrylic on canvas
62 × 84 (157.5 × 213.5)

77
**Vermeer, Portrait of the Artist
in his Studio**
1968
Acrylic on canvas
105 × 87 (266.5 × 221)

78
School of Athens
1972
Oil and acrylic on canvas
67 × 94½ (170 × 240)

79
Untitled Souvenirs, Europe
1973
Oil on canvas with objects attached
96¼ × 68¼ (244.5 × 173.3)

80
SS France
1974
Oil and mixed media on canvas with
objects attached
72 × 57½ (183 × 146)

81
Age of Catastrophe
1976
Oil on canvas
60 × 96 (152.5 × 244)

82
Camels and Goats
1980
Oil on canvas
66½ × 100 (169 × 254)

83
Arizonac
1981
Oil on canvas
80 × 105 (203 × 266.5)

84
Farewell to Crete
1984
Oil on canvas
80 × 164 (203.2 × 416.6)

85
Love Boat
1985
Oil on canvas
50 × 80 (127 × 203.2)

86
**Macaws, Bengals,
with Mullet**
1982
Oil on canvas
120 × 80 (305 × 203)

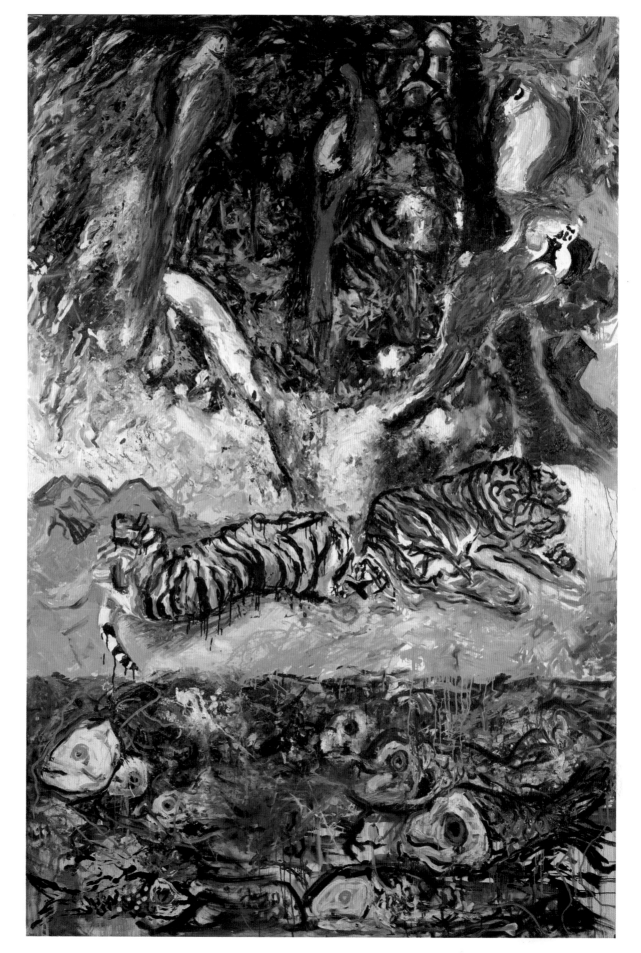

John Murphy

Looking at John Murphy's paintings is like being locked out of one's own home and suddenly finding a back window ajar. Wide fields of colour conform to one tenet of Minimalism, the reduction of content to the surface. As with Brice Marden and several others there is talk of the paint surface as skin. Yet Murphy is not limited by this concept; the lessons of Minimalism are but one aspect of his work.

Despite the almost casual assimilation of American ideals, Murphy places himself firmly within the European tradition. Michael Newman elaborates, tracing the artist's 'lineage within a specifically European Symbolist-based conceptual tradition which descends from Mallarmé and Jarry, through Duchamp, Picabia and Magritte, to Marcel Broodthaers . . . Yves Klein and Piero Manzoni'. The critic claims these men are all preoccupied with 'the relationship between vision, things and language'.[1]

Murphy's paintings rely strictly on duality. The image doesn't tell the whole story. The theme of *A Null Jewel of Reverie (Epidendrum brassavolae)* (1984) is not just a small orchid falling through blue space. The title talks of reverie, but balances this with the cold blast of the plant's formal classification. The work is allusive; interest in the painting is maintained by a constant sparring of ideas. Nature battles with culture as a petal falls through generations of meanings, none of which can be pinned down.

The most constant pairing is between image and surface. *Sunk into Solitude* (1987, Collection F.R.A.C. des Pays de la Loire) is the most potent example. Ostensibly it depicts the horns of a rhinoceros without its body. It begs the question, 'Where is the rhino?' The answer lies in the skin of the paint. The surface and image are given equal weighting, though once again there is a see-saw effect. As in *I have carved you on the palm of my hand* (1985), the surface and image win ascendancy alternately.

The scale of the work and the large areas of coloured space concentrate attention on the often obscure item that becomes the focal point almost by default. Murphy scavenges for his double-edged images and titles from advertising, television, pop songs, literature and art history. His draughtsmanship frequently echoes the Old Masters. The drawings in *'In my throat', said the Moon* (1984), *And the Tongue, And the Throat* (1984) and *Let him feel the Tongues of Longing* (1985) are taken from an exhibition of Umbrian drawings he saw in Venice. The artist is constantly stretching across time to find the most apt contradictions, visual and verbal, to give painting a new life and underline the fragmentary nature of our existence.

1 Whitechapel Art Gallery catalogue, London 1987 and Arnolfini, Bristol catalogue 1988, *John Murphy*.

87
An Indefinable Odour of Flowers Forever Cut
1982–84
Oil on linen
84 × 73 (213 × 185)

88
The Nocturnal Inscription Represents . . .
1981–83
Pastel on paper dry-mounted on board
One of twelve panels, each $53\frac{3}{4} \times 45\frac{7}{8}$
(136.5 × 116.5)

89
A Null Jewel of Reverie *(Epidendrum brassavolae)*
1984
Oil on linen
78 × 66 (198 × 168)

90
Stuck in the Milky Way
1983–85
Oil on linen
96 × 84 (244 × 213)

91
The Shallow Ear Quickly Overflows
1984
Oil on linen
78 × 66 (198 × 168)

92
'In my throat', said the Moon
1984
Oil on linen
78 × 66 (198 × 168)

93
And the Tongue, And the Throat
1984
Oil on linen
78 × 66 (198 × 168)

94
Warm Explosion In My Black Siberia
1985
Oil on linen
96 × 84 (244 × 213)

95
Let him feel the Tongues of Longing
1985
Oil on linen
104 × 72 (264 × 183)

96
I have carved you on the palm of my hand
1985
Oil on linen
78 × 66 (198 × 168)

Avis Newman

The title of Avis Newman's split polyptych, *Figure who no one is . . .* (1983–84), is typically allusive. Orpheus' descent into darkness to find art has been held up as an example by many artists, but several other ramifications of the Orphic myth are relevant to the work. In one version of his death, he is torn to pieces by Bassarae (fox-maidens) as a sacrifice, an early forerunner of Communion. The dismemberment and reassemblage of the figure is implied in the work, but the inference that there was a whole in the first place is nullified by a constantly shifting focus and transformations in scale. Could it be the figure who no one is . . .?

In contrast to the expansive canvases there are small hermetically sealed boxes, which might at first sight be mistaken for collector's display cases. There is a possible link between the large and small work. The preoccupation with scale is allied to the constant play between the actual and the depicted, matter and sensation, the desire to possess and its impossibility. The juxtaposition of object and title nag at the viewer's incomprehension. *The Stuff of Dreams* (1989) could be a depiction of the darkest night but is a pile of soot compressed against glass and contained by a blackened frame. A 'white Malevich' composed of salt is entitled just as cryptically, *Earth of Paradise* (1989). Perhaps the most provoking is a snail-shell suspended and held by glass in the centre of a transparent box. There is no snail, only a shell of understanding.

When *Figure who no one is . . .* was shown at London's Serpentine Gallery, it was set round the four walls of the North Gallery, so that it could never all be seen at once.[1] Comprehension can only be partial. The work implies there is an order and a structure to the universe, but the collected parts we experience are constantly in flux. Like Richard Deacon, Newman has taken a precept from Donald Judd and inverted it. Using a construct that already existed did not resolve the impasse induced by Minimalism. There is an echo of Judd's proclamation, 'The whole's it', but – unlike Judd – Newman does not find it a problem that 'anything that is not absolutely plain begins to have parts in some way'. The work glories in the parts that refuse to be viewed as mere fragments of the whole. The images represent nothing other than their own entity. Nothing is permanent.

1 Serpentine Gallery catalogue, London 1984, *Coracle Press Gallery, Matt's Gallery and Graeme Murray Gallery at the Serpentine.*

97
Figure who no one is . . . I (South)
1983–84
Acrylic, pencil, ink, charcoal and collage on canvas
108 × 144 (274.3 × 365.7)

98
Figure who no one is . . . II (West)
1983–84
Acrylic, pencil, ink, charcoal and collage on canvas
108 × 296 (274.3 × 751.8)

99
Figure who no one is . . . III (North)
1983–84
Acrylic, pencil, ink, charcoal and collage on canvas
108 × 168 (274.3 × 426.7)

100
Figure who no one is . . . IV (East)
1983–84
Acrylic, pencil, ink, charcoal and collage on canvas
108 × 144 (274.3 × 365.7)

101
Figure who no one is . . . V (East)
1983–84
Acrylic, pencil, ink, charcoal and collage on canvas
108 × 144 (274.3 × 365.7)

Paula Rego

'How one was as a child is how one is now', Paula Rego maintains. 'One modifies the childhood a bit, corrects certain abuses.' *The Maids* (1987) shows how she does this. Titled after Jean Genet's play, though based on a rather free adaptation performed in Hampstead, she explains that, 'It's about the servant/ master relationship. Who runs whom? Who is dependent on whom?'

Rego resurrects an ogre from her Portuguese childhood. The schoolteacher, Donna Violeta, came to the Rego house twice a week to teach arithmetic, geography and Portuguese. 'She had her hair done in a kind of a banana at the back of the neck', Paula recalls. 'It rolled up. She was as ugly as sin. She had a little moustache and a big bosom. I was so frightened of her. I had to learn everything by heart. If I got anything wrong – slap – slap. Of course the more she slapped me the less I remembered – obviously because you go into a panic and freeze. Maybe that's what I am trying to do – dispose of that horrible creature after all these years.' Neither this belated assassination nor Genet's adapted plot supply the full story. There is a man's dressing-gown hanging on the door. 'There must be a man around somewhere', the artist confesses. 'Of course there is something else going on, hidden, hidden in the folds. There are secrets in the material, secrets which get painted into it, things you cannot name. It's not just that you cannot name them; you don't know what they are.'

Secrets, their purging and perpetuation, are at the centre of Rego's work. There is a clash of worlds in her paintings, Portugal against England, fairy stories versus reality and her childhood pitted against her often harsh adult life. In the last ten years she has gone through a series of dramatic changes as she has endeavoured to find a style that could contain the explosion of conflicting forces within her. From 1985 onwards she began to ground her figures, which slowly emerged as human beings rather than the host of animals and imagined creatures that had previously inhabited her pictures. The menacing undercurrent that had long distinguished her work came closer to the surface.

Genet's *Maids*, first published in 1954 when the artist was at the Slade, has much in common with Rego's recent paintings. Both writer and painter walk through the door between fantasy and reality with casual ease; both reveal a vicious world with the most delicate twists of the knife. The paintings of the last two years bring a gust of the fifties or even forties with them. The rooms, clothes and objects are reminiscent of her youth and the days when she set up as an artist. She has used her past, but the abuse that is revealed ensures a heady blend between the past and the present.

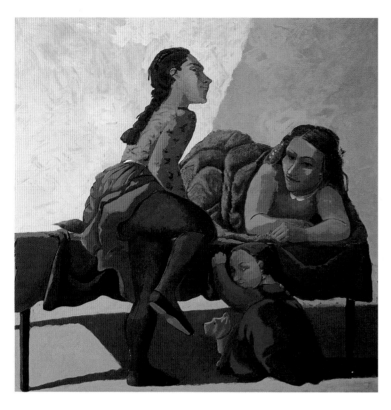

102
Looking Back
1987
Acrylic on canvas-backed paper
59 × 59 (150 × 150)

103
The Policeman's Daughter
1987
Acrylic on canvas-backed paper
84 × 60 (213.4 × 152.4)

104
The Maids
1987
Acrylic on canvas-backed paper
84 × 96 (213.4 × 243.9)

105
The Family
1988
Acrylic on canvas-backed paper
84 × 84 (213.4 × 213.4)

Sean Scully

'I spent five years making my paintings fortress-like', says Sean Scully.[1] By the eighties, with his emigration to America well behind him, he became more prepared to take risks. While maintaining their size and ambition, he has injected a surprising lyricism into these rock faces of paintings.

In the early seventies Scully's grid paintings gained much critical approval; they were almost made-to-measure for the period's formalist theories. Yet the antipathy of one British critic contributed to his flight to America. Masking tape, acrylics and sombre colours helped to ensure the impenetrability of the early American work, but all were dropped in the late seventies to develop a mature, independent art.

Scully is one of the few artists of the eighties who can justifiably claim to have revitalized abstract art. As *No Neo* (1984) protests, he is not interested in Neo-Expressionism, Neo-Geo or any faddish or revivalist movement. His paintings overwhelm opposition with their universal appeal. As Scully writes, 'An artist who can provoke empathy is the one who simply completes your thought or makes visible our desire (yours and mine). I am not trying to say anything different from what you want to say. I want to say the same thing.' He is prepared to court the accusation of being decorative in the pursuit of pure abstraction. He is attempting to release undiluted emotion and makes a play of his vulnerability in doing so.

'Paint is the surface of culture', Scully proclaims, yet he proceeds to break this very surface, revealing it as fiction. The backs of the paintings are like building yards with his stretchers being the scaffolding needed to support such massive superstructures. Panels are inserted, but he is careful not to let them project too far. They still remain frontal. He simply wants to interrupt the surface, to acknowledge that art is not a smooth march.

Though Scully is firmly rooted in the twentieth century, standing in the line of Mondrian, Rothko, Newman, Agnes Martin, Marden, Ryman and Jasper Johns, there is a surprising alliance with Italian fourteenth-century painters. *Maesta* (1983, Edward R. Broida Trust) most clearly announces this connection, as it is named in homage to the central panel of Duccio's fifty-four-panel masterpiece of 1311, but *The Bather* (1983) is another 'Italian' painting recalling an incident in Tuscany. There may be an element of jest in another of the painter's titles, *All There Is* (1986), but there can be little doubt that he wishes to make the most permanent of objects, the lasting work of art.

1 From conversations with Carter Ratcliff, 1987–88.

106
The Bather
1983
Oil on canvas
96 × 120 (243.8 × 304.8)

107
By Night and By Day
1983
Oil on canvas
$97\frac{1}{2}$ × 142 (247.7 × 360.7)

108
Outback
1984
Oil on canvas
102 × 109 (259 × 276.9)

109
Standing
1986
Oil on canvas
Three parts, each 113 × 93 (287 × 236.2)

110
Red Earth
1985
Oil on canvas
83⅞ × 96 (213 × 244)

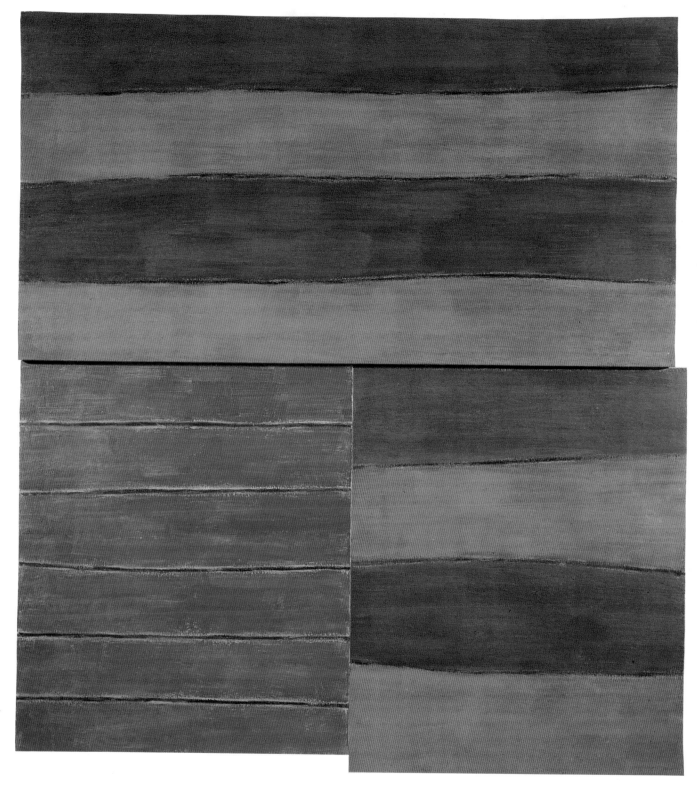

111
Heat
1984
Oil on canvas
108 × 96 (274.4 × 243.8)

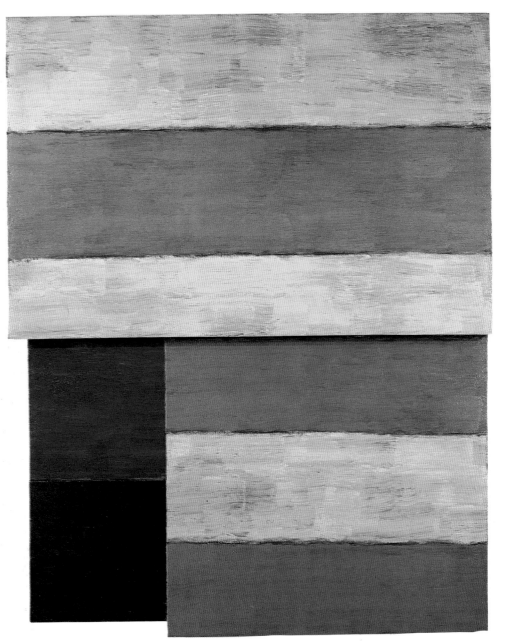

112
All There Is
1986
Oil, glue and size on linen
$105\frac{1}{2} \times 84\frac{1}{4}$ (268 × 214)

113
Empty Heart
1987
Oil on linen
72 × 72 (182.9 × 182.9)

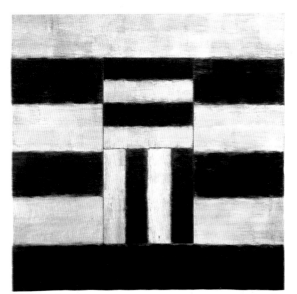

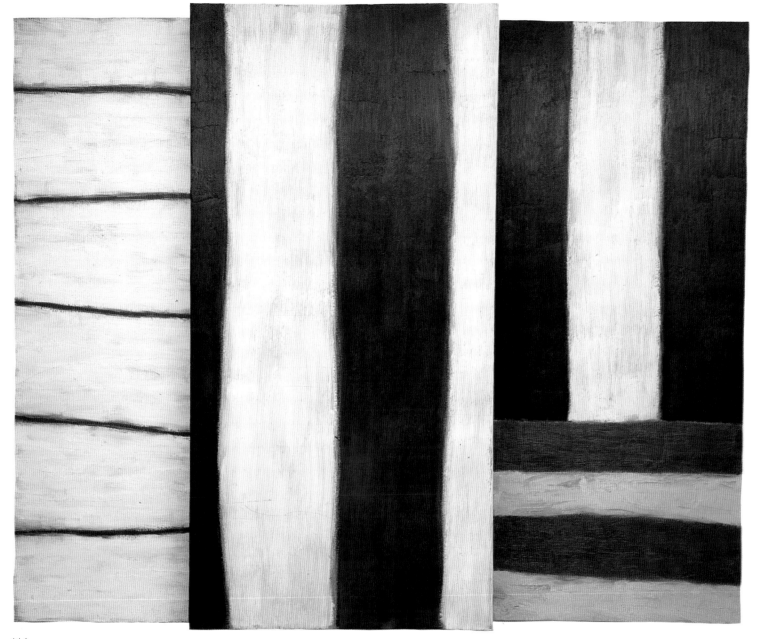

114
No Neo
1984
Oil on canvas
96 × 120 (243.8 × 304.8)

Carel Weight

'I don't like the art world very much', says Carel Weight. 'I don't like the dealers and I don't like the critics.'[1] Despite presiding over the Royal College of Art as its Professor of Painting from 1957 to 1973, Weight has steered an independent course. His psychologically coloured vision has little in common with those of the other artists represented in the Collection.

Kitaj and Caulfield (alongside Hockney and many of the Pop artists) were students at the College during Weight's reign. He had joined the staff in 1947, so Auerbach, Kossoff and Morley passed through the school while he was teaching there. Weight never looked for followers; one of his main contributions as a teacher was to ensure a healthy eclecticism and encourage individuality.

Witches, angels, ancient goddesses and phantoms inhabit Weight's paintings, whether they are physically present or not. His is a haunted world in line with that of other English eccentrics such as Blake, Dadd and Stanley Spencer. For influences one has to turn to the North, to Bosch, Brueghel and Munch, from whom he has gained an added anxiety and humour, but even they should not be overemphasized. Few can doubt the authenticity of his vision, which appears to have hardly changed since the early thirties.

Surprisingly Weight gains strength from inconsistency. Even Escher could not have convincingly joined the walls together in *The Dream* (1986), but the jarring information adds to the tension between hunter and pursued. The artist is not afraid of purloining unrealistic devices to transform otherwise commonplace scenes. In *The Bag Snatcher* (1986), for instance, he unashamedly borrows a futuristic technique to heighten the drama written on the victim's face.

Suburban scenes touched by surrealism supply a high percentage of Weight's subjects, but when he departs to the country the sense of danger is often heightened. Brueghel and Bosch are more strongly evoked, but there is invariably some reminder of modern life. The artist does not hold up much hope for the *Bid for Freedom* (1985). The virulent purple clouds are more reliable indicators of the future than the promise of the golden wheat beneath the fleeing woman's feet. There is no escape from Weight's vision; it casually adopts the prophetic certainty of Isaiah and Ezekiel.

1 In an interview of October 1981 with Norman Rosenthal.

115
Foxwood
1968
Oil on canvas
36 × 39 (91.4 × 99)

116
Thoughts of the Girls
1968
Oil on canvas
$65\frac{3}{4}$ × 54 (167 × 137)

117
Bid for Freedom
1985
Oil on canvas
55 × 72 (139.7 × 182.9)

118
Guardian Angel
1984
Oil on canvas
50 × 40 (127 × 101.6)

119
Crucifixion II
1981
Oil on canvas
$83\frac{1}{2} \times 46$ (212 × 116.8)

120
The Dream
1986
Oil on canvas
56 × 56 (142.2 × 142.2)

121
The Bag Snatcher
1986
Oil on board
48 × 48 (121.9 × 121.9)

122
Winter Walk
1987
Oil on board
48 × 48 (121.9 × 121.9)

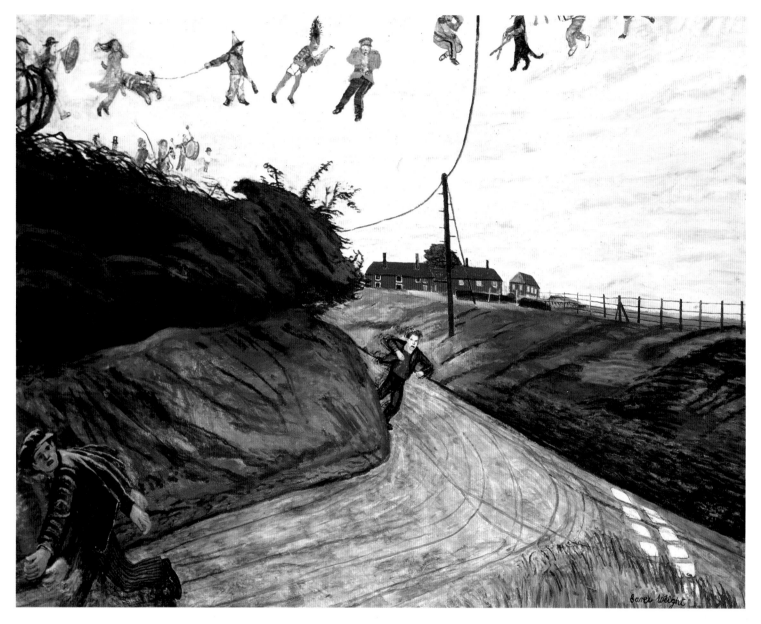

123
Invasion
1987–88
Oil on canvas
48 × 60 (121.9 × 152.4)

124
Primavera
1988
Oil on board
48 × 48 (122 × 122)

125
Navigation
1977
Oil on canvas
78¾ × 94½ (200 × 240)

126
Plants
1981
Oil on canvas
78¾ × 98½ (200 × 250)

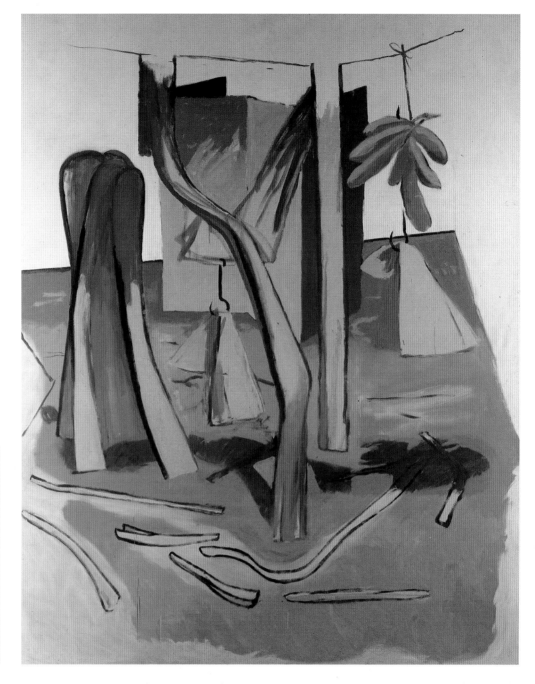

127
Höhle
1980
Oil on canvas
$78\frac{1}{2} \times 78\frac{1}{2}$ (199.3 × 199.3)

128
Tatters
1981
Oil on canvas
$98\frac{1}{2} \times 78\frac{3}{4}$ (250 × 200)

129
Griffin
1982
Oil on canvas
$98\frac{1}{2} \times 78\frac{3}{4}$ (250 × 200)

130
Knot
1984
Oil on canvas
$78\frac{3}{4} \times 86\frac{1}{2}$ (200 × 220)

131
Callot Harridan
1984
Oil on canvas
$78\frac{3}{4} \times 86\frac{1}{2}$ (200 × 220)

132
Callot Fusilier
1983
Oil on canvas
$98\frac{1}{2} \times 98\frac{1}{2}$ (250 × 250)

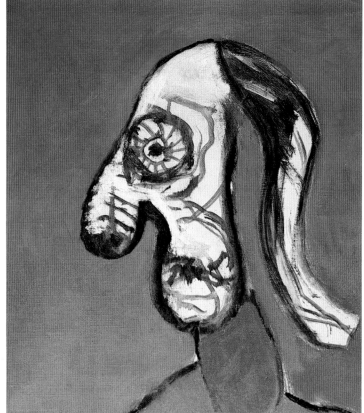

133
Head (No. 1)
1985
Oil on canvas
$17\frac{1}{4} \times 15\frac{1}{2}$ (43.8 × 39.4)

134
Head (No. 3)
1985
Oil on canvas
$17\frac{1}{4} \times 15\frac{1}{2}$ (43.8 × 39.4)

135
Head (No. 5)
1985
Oil on canvas
$17\frac{1}{4} \times 15\frac{1}{2}$ (43.8 × 39.4)

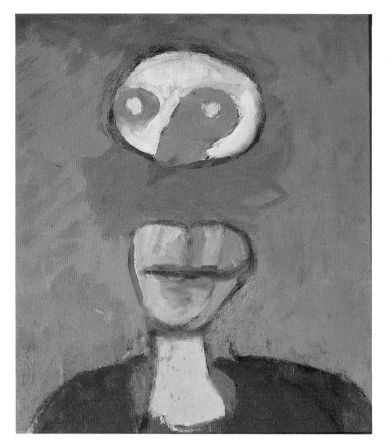

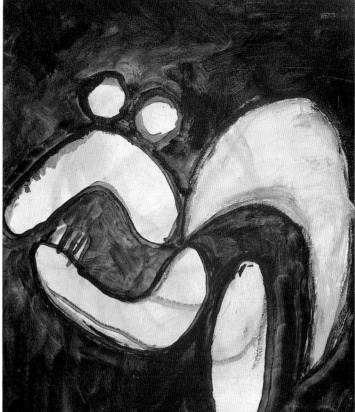

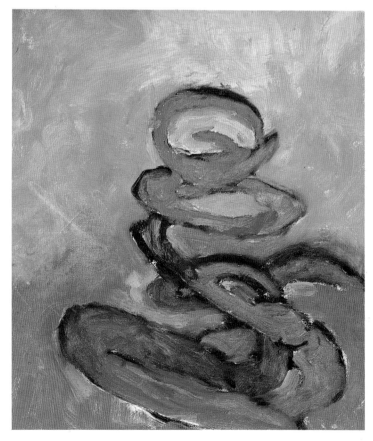

136
Head (No. 7)
1985
Oil on canvas
$17\frac{1}{4} \times 15\frac{1}{2}$ (43.8 × 39.4)

137
Head (No. 8)
1985
Oil on canvas
$17\frac{1}{4} \times 15\frac{1}{2}$ (43.8 × 39.4)

138
Head (No. 9)
1985
Oil on canvas
$17\frac{1}{4} \times 15\frac{1}{2}$ (43.8 × 39.4)

Tony Cragg

Man functions in everyday life without knowing what the objects around him are, he is hardly aware of the political situation, the social reality, the chemical problems, even basic things like what electricity is. People are constantly talking about progress, yet they seem to forget that the progress they are talking about is only material, whereas man himself, his basic condition, hardly evolves. . . . We should not let the prime function of our lives just be materialistic, get rich, be powerful. The quality of creative imagination can improve, so can our appreciation of the world. Tony Cragg[1]

Tony Cragg's *Sermon* (1985) warns of galloping consumerism. The state of the environment is a persistent theme, but his is a far from straightforward vision. He perceives environmental problems as 'just one by-product of our lack of respect and understanding towards the world we live in'.

There is a misleading irony in titles like *Sermon* (1985), *Evensong* (1986) and *Minster* (1987). He is opposed to religion, but he could be accused of developing an extreme form of pantheism, urbanism, for he finds an echo of nature in industry. His materials are man-made or 'man-modified'. He uses them, not only to highlight their profusion and reveal an unlikely beauty, but to heal an ever-widening gap between our fast-changing surroundings and our channelled existence.

Cragg trained as a scientist. From 1966 to 1968 he worked as a laboratory technician for the Natural Rubber Producers' Research Association. He concluded that 'what science lacks is perceivable images'. Man becomes more and more isolated as the information builds up around him. The cheap plunder of an untapped area doesn't interest the artist; he is seeking to bring art and science together as they were until the seventeenth century. He achieves this through a process of synthesis in *Untitled (Conch shell)* (1988). A shellfish, albeit fashioned in steel, sits on some industrial debris, recalling a story Annelie Pohlen relates of a visit to Cragg's Wuppertal studio. He showed her a small ring-shaped polystyrene object that he had picked up on one of his walks along a nearby river. Nestled inside it was a tiny mussel.[2]

Nature, with its rapidly changing face, remains Cragg's ultimate source. His materials were all originally invented as substitutes for natural products. The division between the natural and synthetic blurs in the desire to find visual explanations for the 'information world'. The barriers are broken to yield the artist's legendary diversity. 'I make sculptures because they are not there', he quips. He creates objects that don't already exist in the natural or functional world. The previous role of the materials is a necessary hurdle. The imagery must be strong enough to overcome it and break man's enslavement to function.

Cragg does not present us with neatly packaged answers. His scientific background has prepared him for the necessity to experiment constantly, but art is rarely a precise science, as *Instinctive Reactions* (1987) highlights. The artist may use a technique as thorough as that of countless test-tube experiments, but in the final analysis it is instinct that leads to the final solution, nature and science once more working together.

There are no new continents to discover. As the planet offers fewer natural areas for exploration, as it is flooded with more people and objects, man is increasingly rocked back on to the only limitless space he has, what Cragg describes as 'the freedom between the ears'. This has led him to declare that 'we are living in a new epoch for sculpture'. The previous generation of sculptors like Judd, Flavin, Nauman and Long[3] has become famous for making non-art materials available to artists. Cragg himself initially won acclaim as the pioneer of plastics, but has refused to be limited by this. He has harnessed Conceptualism and other seventies' ideas to his own needs. He aims to expand the brain.

'All individuals have to make a picture of the world and their existence in it', Cragg maintains, updating Beuys' proclamation that everyone is an artist. Cragg is a realist. Every man and woman may have the potential to be an artist, but they do not appear to be using it. His sculpture attempts to remedy this. It assaults the modern way of life, but offers rich alternatives.

1 Interview with Demosthene Davvetas, 1985.
2 'Possibilities and New Ways', *Tony Cragg*, Brussels and Paris 1985.
3 Although Long is only four years older than Cragg, he came to prominence much earlier.

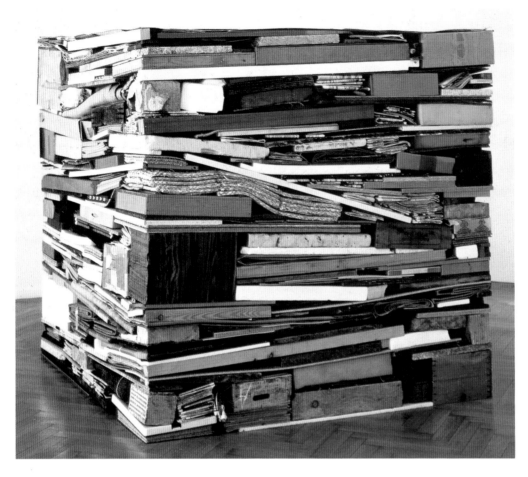

139
Stack
1975
Mixed media
$78\frac{3}{4} \times 78\frac{3}{4} \times 78\frac{3}{4}$ (200 × 200 × 200)

140
Sermon
1985
Plastic drainpipes, galvanized metal,
letterpress printing box
$57\frac{1}{2} \times 102\frac{3}{8} \times 98\frac{3}{8}$ (146 × 260 × 250)

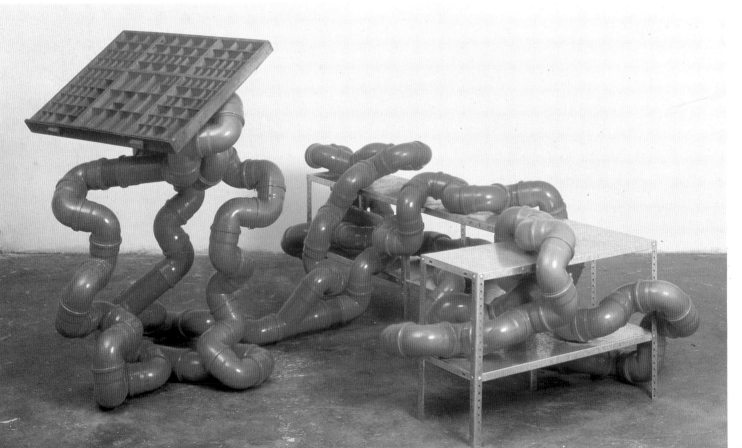

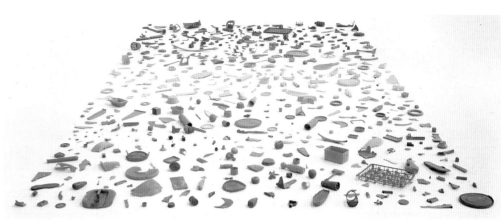

141, 142 *(detail)*
Spectrum
1983
Plastic
$255\frac{7}{8} \times 137\frac{3}{4}$ (650 × 350)

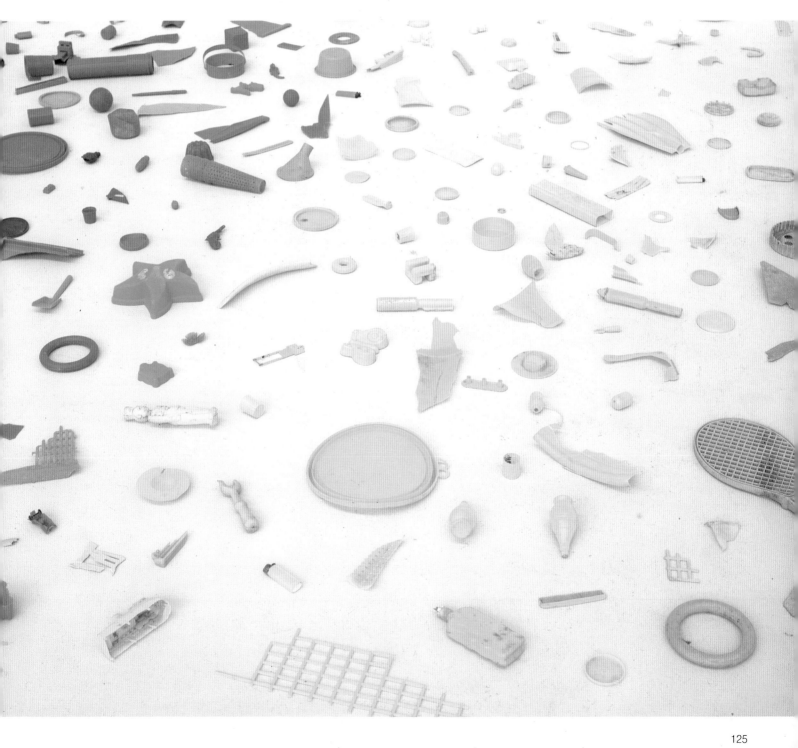

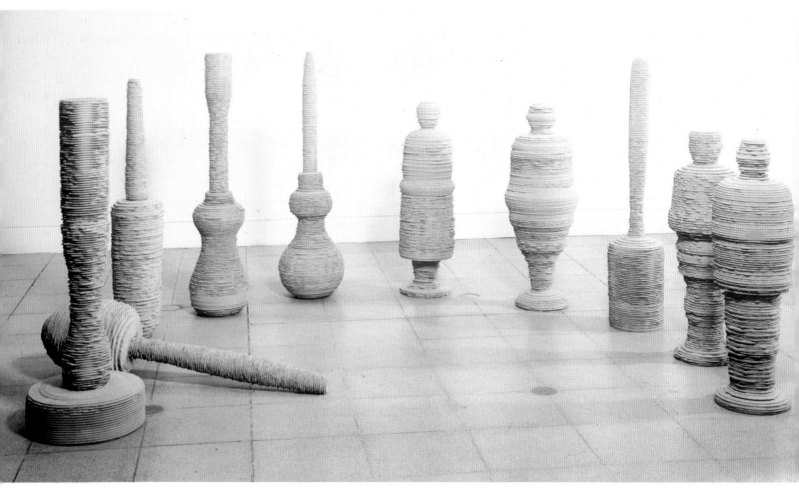

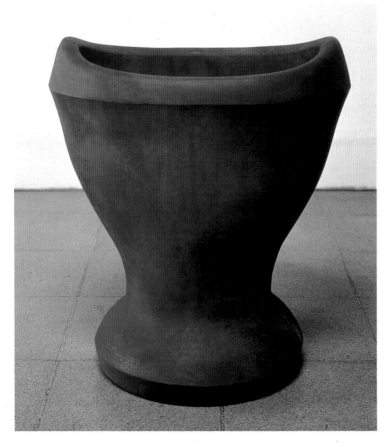

143
Tools
1986
Sandstone
$39\frac{3}{8} \times 126 \times 98\frac{1}{2}$ (100 × 320 × 250)

144
Eye Bath
1986
Cast iron
$21\frac{5}{8} \times 22 \times 15\frac{3}{4}$ (55 × 56 × 40)

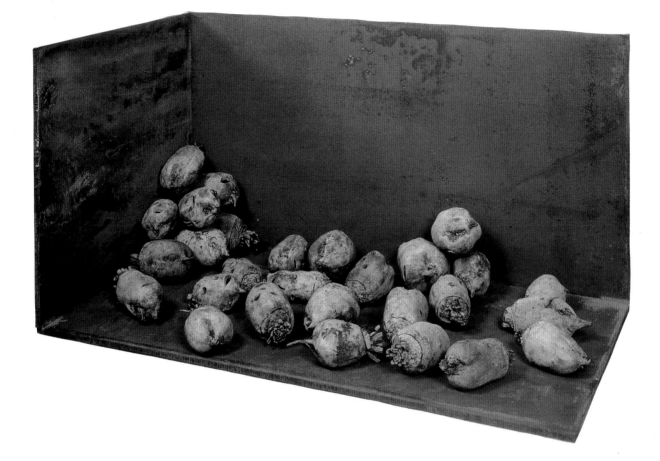

145
Inverted Sugar Crop
1987
Bronze, steel
$39\frac{3}{8} \times 78\frac{3}{4} \times 39\frac{3}{8}$ ($100 \times 200 \times 100$)

146
Evensong
1986
Corten steel
$86\frac{1}{2} \times 67 \times 58\frac{1}{4}$ ($220 \times 170 \times 148$)

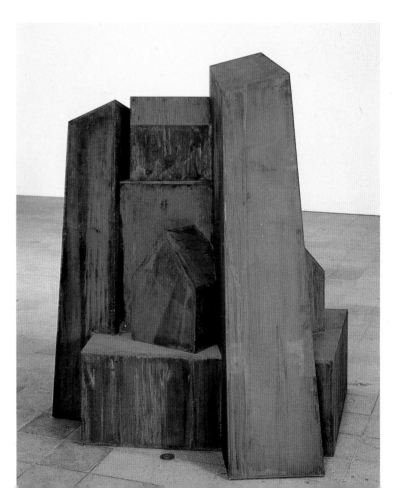

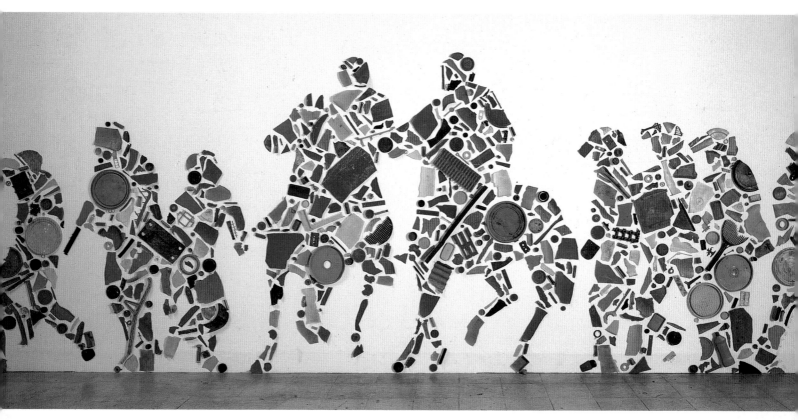

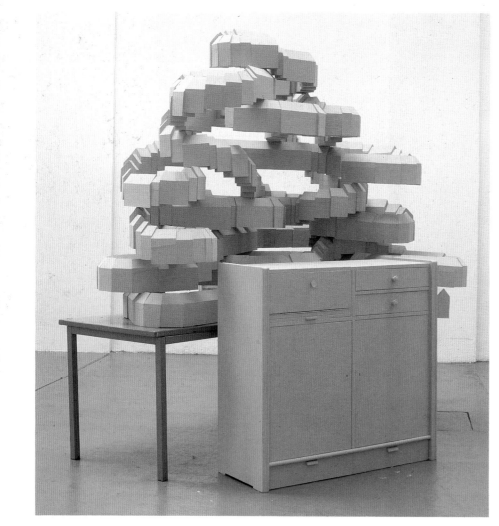

147 *(detail)*
Riot
1987
Plastic
$92\frac{1}{2} \times 617\frac{3}{8} \times 27\frac{1}{2}$ (235 × 1568 × 70)

148
Città
1986
Hardboard, wood, paint
$98\frac{3}{8} \times 78\frac{3}{4} \times 102\frac{1}{2}$ (250 × 200 × 260)

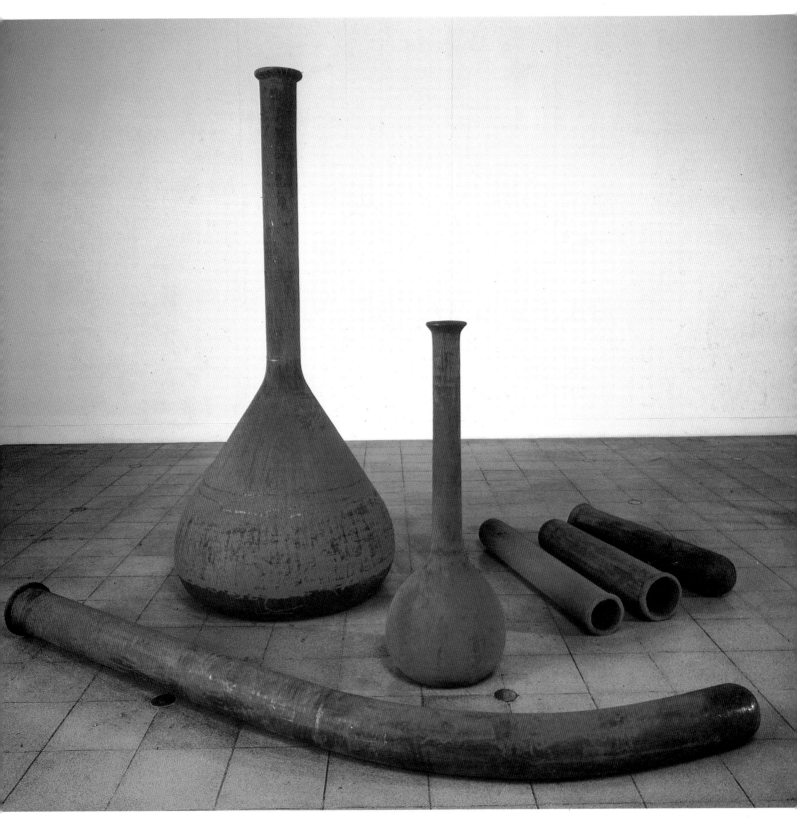

149
Instinctive Reactions
1987
Cast steel
$94\frac{1}{2} \times 137\frac{3}{4} \times 177\frac{1}{8}$ (240 × 350 × 450)

150
Brick Built
1987
Cinder block, pressed-sand brick
$177\frac{1}{8} \times 48 \times 38$ (450 × 122 × 97)

151
Untitled (Conch shell)
1988
Steel
$43\frac{3}{8} \times 86\frac{3}{4} \times 78\frac{3}{4}$ (110 × 220 × 200)

152
Minster
1987
Rubber, stone, wood, metal
$82\frac{1}{4}$ h. × $31\frac{1}{2}$ dia., $76\frac{3}{4}$ h. × $19\frac{3}{4}$ dia., $90\frac{1}{2}$ h. × $17\frac{3}{4}$ dia., $118\frac{1}{4}$ h. × $30\frac{3}{4}$ dia.,
120 h. × $22\frac{3}{4}$ dia. (209 × 80, 195 × 49, 230 × 45, 300 × 78, 305 × 58)

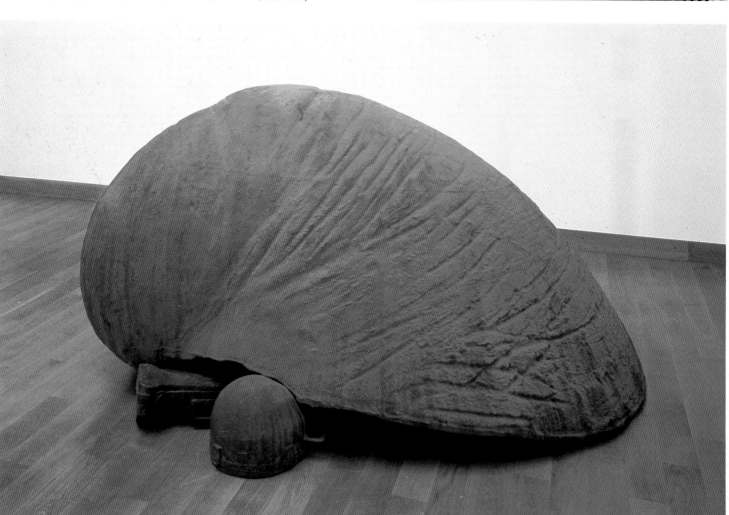

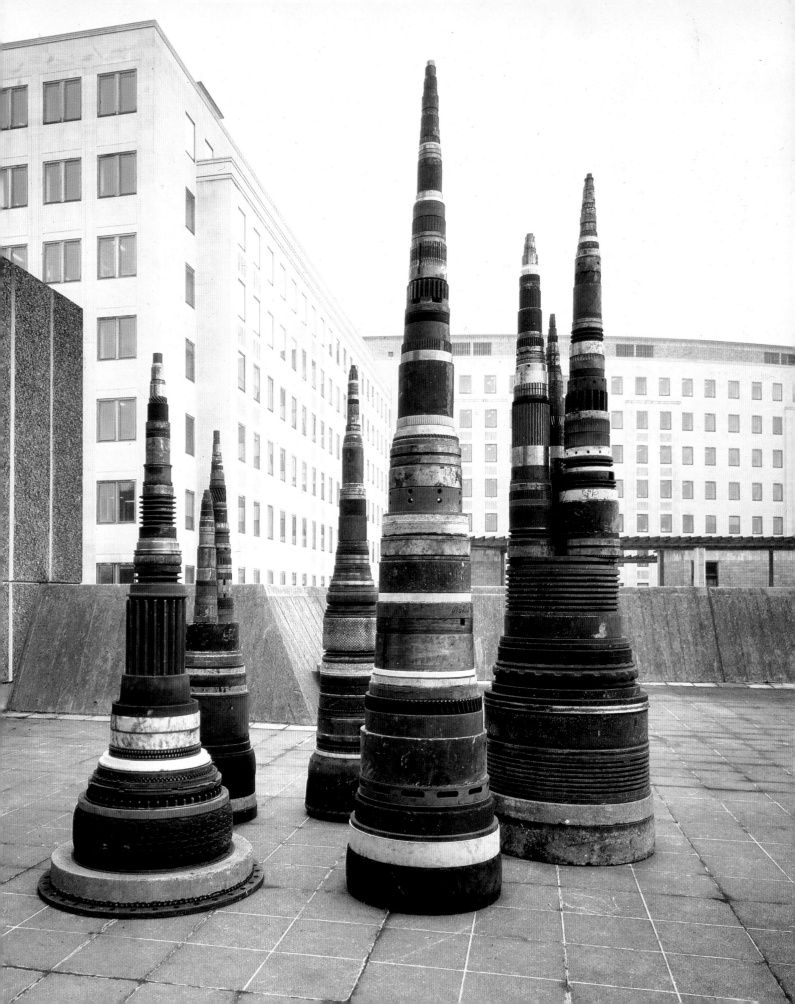

Grenville Davey

Man has fallen. The echo of the gates of Paradise clanging shut can still be heard, repeated time and time again. We are forever locking doors behind us, bolting windows and blocking out the outside. It might seem archaic to describe Grenville Davey's ultra-modern vision in such biblical terms, but his sculpture is made up of manholes, seals and rails, all barriers.

Davey refers to those prelapsarian days when technical advances could be incorporated into sculpture. He uses ordinary objects as they have a life outside sculpture, yet they are like forbidden fruit. This is made clear in a recent work, *Plain* (1988). It is a large smooth circle like *Purl* (1988), but is indented as though two fingers have picked it up and squeezed the edge. That is impossible because the piece is made of painted steel. The act of touch has been blown up out of all proportion and immortalized in a ball of metal. In Davey's world Adam would have broken his teeth on an oversized apple.

Claes Oldenburg has been cited as an influence on Davey. There are similarities in scale and occasionally in the treatment of subject-matter, but Davey's work refuses to yield instant meanings. He is inviting the viewer to peck away at the sculpture to discover more about it, but he knows full well that the nut will never crack.

Davey is twenty-eight and only owes Oldenburg a second-hand debt. He has been brought up between the towers of his teachers, Richard Deacon and Richard Wentworth. The latter is open in his admiration for Oldenburg, whom he sees as the last of the great European/American sculptors. In his turn, the young sculptor is more interested in the allusive Wentworth and injects some of Wentworth's delayed humour into Deacon's grand statements.

Davey doesn't seek to magnify the mundane, but he does just that to break down people's expectations. He is constantly surprised by the way people read objects, what they don't see. Manholes are usually unobstrusive. *Cover* (1986–87) sits on the gallery floor. It is not flush with the ground, so it is artificially raised. It has no function. It has bolts, but they too sit uselessly on the surface. *Grey Seal* (1987) is equally incongruous. In isolation the objects assume a certain importance; it is a visual twist on Samuel Beckett. It is as though he has taken a page of prose and cut every word, so only the punctuation is left.

153
Untitled Pair
1987
Spun steel, cellulose paint
Each 1½ d. × 35 dia. (4 × 89)

154
Seal
1987
Spun steel, rubber, cellulose paint (pair)
Each 8¾ d. × 28¼ dia. (22.2 × 71.8)

155
Cover
1986–87
Rusted spun steel, bolts
3 h. × 30½ dia. (7.5 × 77.5)

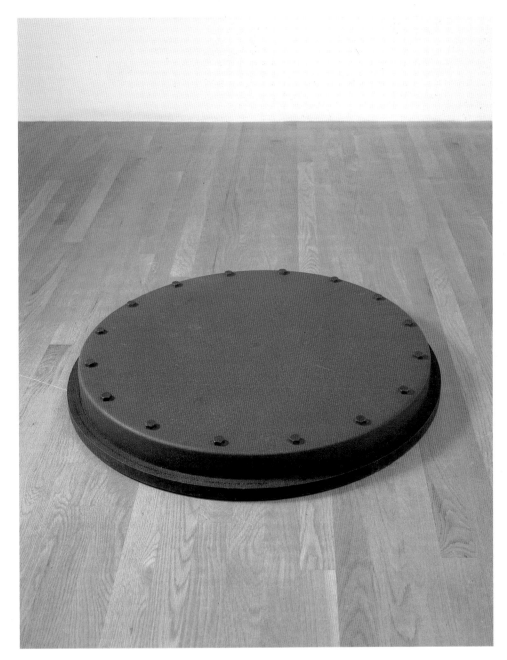

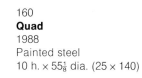

160
Quad
1988
Painted steel
10 h. × 55⅛ dia. (25 × 140)

156 *(above)*
Rail
1987
Steel, steel tube, cellulose paint
40 × 100¾ × 2⅛ (101.5 × 256 × 5.5)

157 *(right)*
Red Giant
1988
Painted steel
2⅞ d. × 46 dia. (7.5 × 117)

158 *(below left)*
Purl
1988
Painted steel
5½ h. × 48 dia. (14 × 122)

159 *(below right)*
Grey Seal
1987
Stainless steel, gas tube, rubber cord
13 h. × 49 dia. (33 × 124.5)

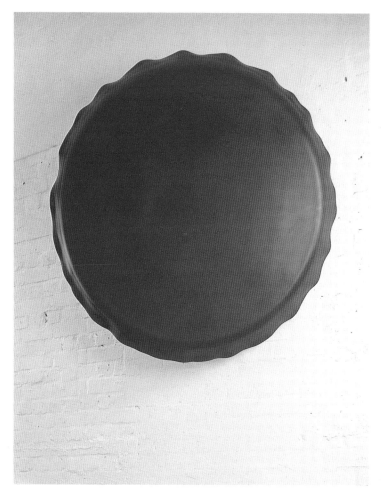

Richard Deacon

The walls of Jericho fell after Joshua's seven trumpets had sounded and the people had shouted with a great shout. The titles of Deacon's works reveal their meaning like that blast of faith, somewhere between the action and the fact. The sculptures offer themselves like a city that has suddenly and unexpectedly lost its defences. Their skin has been torn off and they lie basking in the desert sun before us.

Deacon's mature style emerged in 1980 as if overnight. *Untitled* (1980) and *Untitled* (1981), the first two sculptures he finished after his return from a stay in the United States, display an uncompromising confidence in a new language. Connections may be made with other sculptors and his own earlier work, but neither these nor his year studying history of art at Chelsea School of Art in 1977 can fully explain his understanding of the direction of twentieth-century sculpture. This was triggered by some of this century's most enthusiastic and constructive criticism, Rilke on Rodin.

Deacon's time in the States from 1978 to 1979 proved critical. He used the *Sonnets to Orpheus* as the subject of a series of drawings and Rilke's other writings provided a rich vein of ideas. In the *Rodin Book* the German poet described sculpture as 'only an endless variety of living surfaces'. Deacon subscribes to that, but has developed another idea found in the *Rodin Book* to counterbalance it. Rilke wrote that sculpture 'must be fitted into the surrounding air as into a niche'. Deacon makes large skeletal structures, but it is the space created within and around them that holds the meaning. Air is as important an ingredient in his work as the sheet steel, bronze or laminated wood.

'For the endowment of an object with life of its own', Rilke wrote, 'does not depend on great ideas but upon whether out of such ideas one can create a *métier*, a daily labour, something that remains with one to the end.' Deacon has achieved this welding of concept and technique. His curvaceous, organic forms are riveted and joined with the care of a craftsman. He emphasizes the method of construction as if the very precision of the physical act makes the ideas behind it clearer.

If the Shoe Fits (1981) was the fourth work Deacon completed after coming back from America and the first to be titled. Invariably this and subsequent titles contain an irony and humour which might be thought to be at variance with the highly positive and serious sculpture. In 1982 he began an as yet unfinished series, *Art For Other People*. The artist is careful to distinguish between the series and individual titles, but they do share certain functions. The title *Art For Other People* clearly shows his desire to distance himself from the finished work. He nearly always names the work after he has completed it, indeed naming it helps to decide that it is finished. It gives it a life of its own.

'Naming a thing', he says, 'is more specific than just labelling.' He underlines this in titles such as *For Those Who Have Ears No. 1* (1982–83) and *For Those Who Have Eyes* (1983), invoking Christ's reprimands to those who wilfully ignore what they hear and see.

Deacon's work is difficult to explain away. It has a classical simplicity and an aloof grandeur. It may be far removed from classical ideals, but there is an inherent sense of proportion. He hates awkward, sharp joints; there are rarely straight lines. Nature is echoed in the prevailing organic forms. *For Those Who Have Eyes* could be a three-dimensional diagram from a physics book, explaining the process of sight. Yet science, nature and a classical view of art are all at least one stage removed from his new language.

In the latter half of the seventies Deacon faced the Minimalist/Conceptualist impasse. His art today derives from this confrontation. He still talks of an all-important skin to his works, the Minimalist surface, though he is prepared to call it an 'envelope' as it is not physically present, but implied by the skeletal structure. He works from the outside inwards, so to him the outer perimeters are crucial, but he has broken from the strict laws of Modernism, indeed he has inverted them, holding up the pregnant space within as equally important. He has built on Judd's concern for the 'whole', by finding it in true Existentialist fashion in the perpetual toing and froing between the part and the whole, in the very smallest detail of building an object.

'While assembling a large sculpture on the lawn outside the Serpentine Gallery in London,' Deacon recalls, 'I overheard two young men talking: "Look at that! What's that then, is it ducting?" "Naa, it's art. Look at the way it's put together."' The meaning of his sculpture lies in its construction, the act of will necessary to create the work. He does not start with a lump of stone or wood, but a pile of steel or board. His works of art literally come out of thin air and builders' materials.

161
Untitled
1980
Laminated wood, rivets
118 × 114 × 114 (300 × 290 × 290)

162
Art for Other People No. 2
1982
Marble, wood, vinyl, plastic, rivets
17 × 62¼ × 13 (43 × 158 × 33)

163
If the Shoe Fits
1981
Galvanized and corrugated sheet steel, rivets
60 × 130⅜ × 60 (152.5 × 331 × 152.5)

164
Untitled
1981
Laminated wood
84⅜ × 120 × 55 (215 × 305 × 140)

165
Art for Other People No. 5
1982
Laminated wood
42 × 42 × 72 (106.7 × 106.7 × 183)

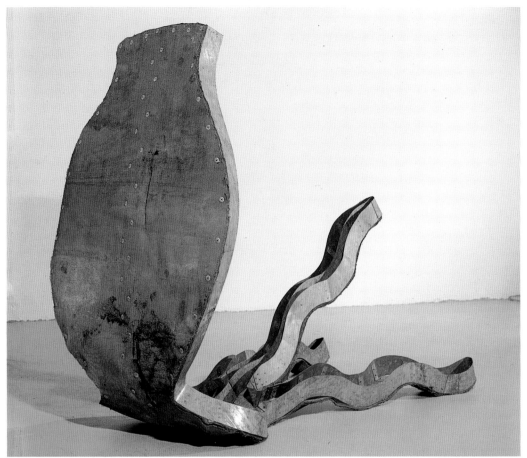

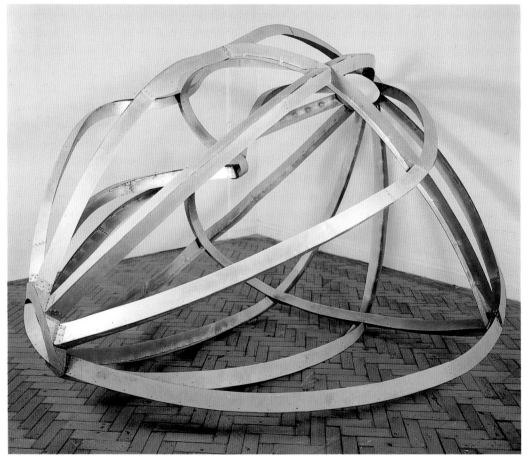

166, 167
Out of the House
1983
Galvanized steel, linoleum, rivets
48 × 24 × 60 (122 × 61 × 152.5)

168, 169 *(below)*
The Heart's in the Right Place
1983
Galvanized steel, rivets
79 × 130 × 92 (200.7 × 330.2 × 233.7)

170
For Those Who Have Ears No. 1
1982–83
Galvanized steel, laminated wood, rivets
84 × 144 × 60 (213.4 × 365.8 × 152.5)

171
For Those Who Have Eyes
1983
Stainless steel, rivets
60 × 60 × 90 (152.4 × 152.4 × 228.6)

172
Two Can Play
1983
Galvanized steel
72 × 144 × 72 (183 × 365.8 × 183)

173, 174
Art for Other People No. 9
1983
Galvanized steel, rivets
21 × 13⅜ × 4⅜ (53 × 34 × 11)

175
Tall Tree in the Ear
1983–84
Galvanized steel, laminated wood, blue canvas
$147\frac{5}{8} \times 98\frac{1}{2} \times 59$ ($375 \times 250 \times 150$)

176
Turning a Blind Eye
1984
Galvanized steel, laminated wood
$36 \times 96 \times 144$ ($91.4 \times 243.8 \times 365.7$)

177
This, That and the Other
1985
Galvanized steel, laminated hardboard,
canvas
Two parts, overall 90 × 156 × 72
(228.6 × 396.2 × 182.8)

178
Fish Out of Water
1986–87
Laminated hardboard
96½ × 137¾ × 74¾ (245 × 350 × 190)

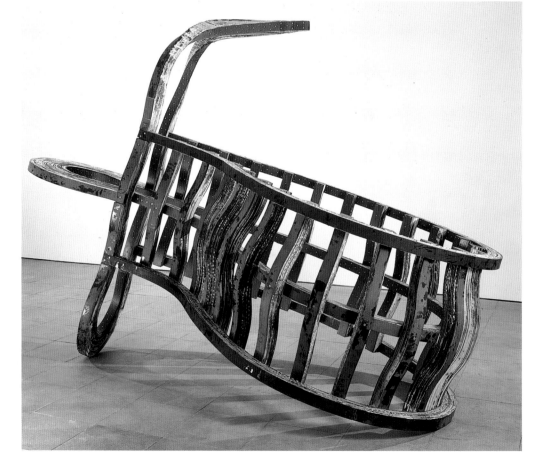

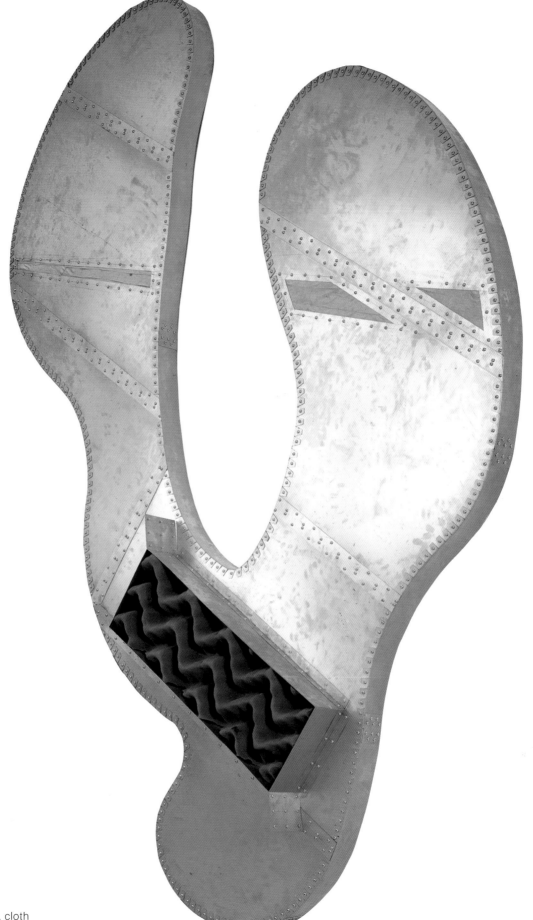

179
The Back of My Hand No. 6
1987
Phosphor-bronze sheet, sponge, cloth
$102\frac{3}{8} \times 63 \times 11\frac{7}{8}$ (260 × 160 × 30)

Julian Opie

Painting was declared an antique mode in the sixties by Robert Morris. This may seem irrelevant to a discussion of a sculptor only born in 1958 who is well known for his use of painting, but the debates that preceded the birth of New British Sculpture are playing an increasingly important role in Opie's work.

Whereas the metal surfaces of Opie's sculpture before 1985 seem to provide an excuse for a profusion of painted images, it could be argued that the work in the Collection, which dates from 1986, demonstrates a new support for Morris' bold statement. This would be misleading. Opie may no longer use drawn images to conceal the process of making sculpture, but he still talks of a 'pictorial imaginary realm'. He has found this in a wealth of shining surfaces and reflections.

In his earlier style Opie frequently satirized the production-line mentality of some abstract art and the 1986 works like *Man Accused of Murder*, *Stock Market*, *Soviet Frost* and *Ceasefire* continue to do so, but his work is becoming increasingly ambiguous. When does irony cease and sincerity set in? This work was also spawned from a genuine fascination with cars and furniture. The use of spray paint on large smooth surfaces introduces the blandness necessary to blur the divisions between art and non-art.

Opie has always delighted in the self-consciousness of art, the demands art immediately places on the viewer. In 1984 the American critic, Kenneth Baker, wrote in the Kölnischer Kunstverein catalogue that, 'Opie's sculpture puts people at ease partly because it is so obviously art.' From 1987 Opie has been severely testing this by using objects that people have been taught to ignore, such as vents, cabinets and display cases. Normally their function precludes any aesthetic significance. You are meant to look inside a display case, not at it. It is usually the television screen that bears the message, not the veneered case.

Opie's latest works appear as the final answers to the explorations of 1987–88. They look like freestanding food display cabinets. He has even plugged them into the mains so that the fronts are lit, inviting the customer to reach for an ice-cold drink, but there is nothing there. In one case he has created a well-lit void out of dark glass, metal sheet and white paint. The work of art is both appetizing and impenetrable. He is reclaiming non-art objects for art, continuing in the spirit of Judd, Nauman, Flavin and his own contemporary Koons, but also producing some clear responses to those now old arguments. His new work does not just challenge painting or indeed sculpture. It takes advantage of our knowledge of previous art and everyday experience and leaves us with an endless series of questions.

180 *(top)*
Man Accused of Murder
1986
Auto-paint on steel
$39 \times 78\frac{3}{4} \times 37\frac{3}{4}$ (100 × 200 × 96)

181 *(centre left)*
Stock Market
1986
Cellulose paint on steel
$39 \times 78\frac{3}{4} \times 19\frac{1}{2}$ (100 × 200 × 50)

182 *(centre right)*
Soviet Frost (White II)
1986
Cellulose paint on steel
$35\frac{3}{8} \times 55 \times 35\frac{3}{8}$ (90 × 140 × 90)

183 *(bottom right)*
Ceasefire (Black III)
1986
Cellulose paint on steel
$35\frac{3}{8} \times 69 \times 35\frac{3}{8}$ (90 × 175 × 90)

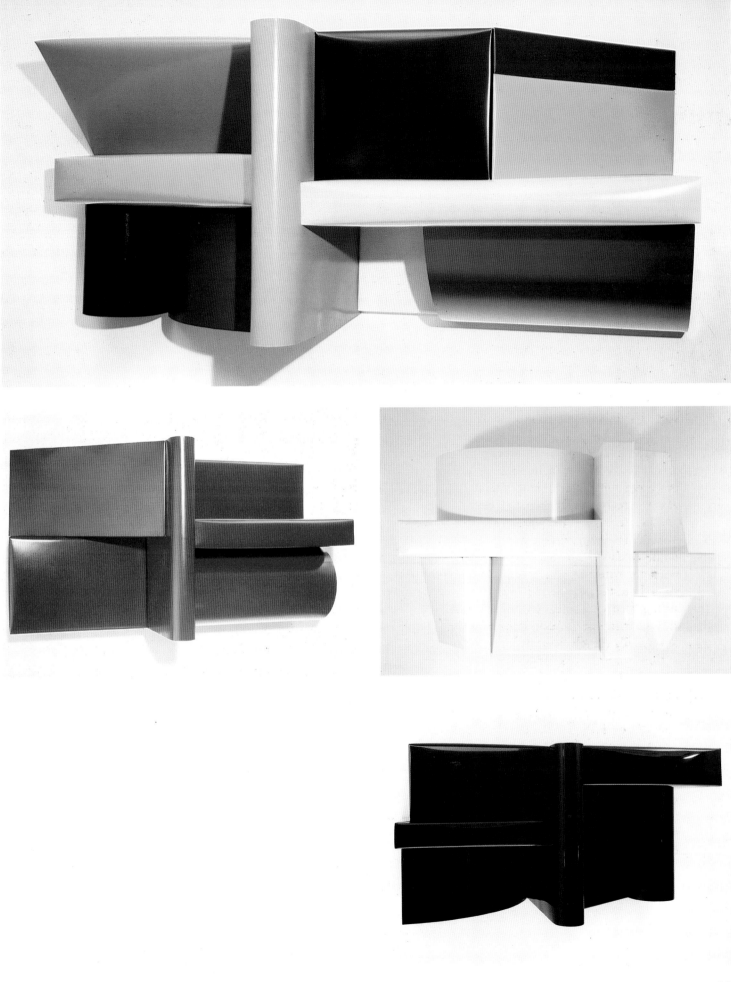

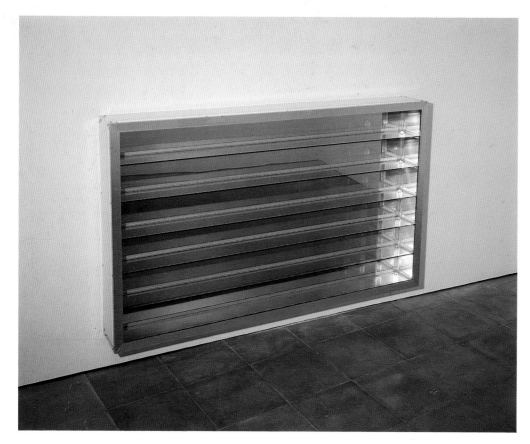

184 *(left)*
J
1987
Glass, aluminium, stainless steel, foam,
pvc, wood
50 × 85½ × 10½ (127 × 217 × 27)

185 *(below left)*
Nightlight
1989
Rubber, aluminium, glass, wood,
cellulose paint, fluorescent light
73⅝ × 48⅜ × 15¾ (187 × 123 × 40)

186 *(below right)*
G
1987
Glass, aluminium, stainless steel, foam,
pvc, wood, cellulose paint
25 × 71¼ × 34 (63.5 × 181 × 86)

187 *(opposite)*
F
1987
Glass, aluminium, stainless steel, foam,
pvc, wood
72 × 31½ × 26⅝ (182.5 × 80 × 67.5)

Richard Wentworth

There is the threat of danger in Wentworth's sculpture. He has people peering into cavernous holes, never sure of what they might find in the urban equivalent of long grass. Sometimes it is merely a dead end, a false bottom, but over-confidence is not encouraged. Steel makes a satisfactory replacement for the surface of water, until the artist cuts a hole and plugs it with a sardine tin, whose projected lid contains the menace of a shark (*Fin*, 1983–84). He does the same with a plate in *Jetsam* (1984). He creates illusions as though the only purpose is to break them. He is surreptitious, hiding behind a succession of manoeuvres, so that no one can be certain what he is saying or who he is. Even his birthplace is in dispute, lying somewhere between the Pacific archipelago of West Samoa and the English university town of Cambridge.

Wentworth, though undoubtedly English, is uncomfortable in England. He quotes from a recent headline in the *Observer*: 'We are rich, free, selfish and unhappy.' Frank Auerbach says his paintings arise out of crises. Wentworth's sculptures originate from similar anxieties, but he reacts in a very different way. While Auerbach pins down passing emotion, Wentworth leaves discomforting messages, which work on a delayed fuse. 'Humour', he says, 'is trying to find pockets of breathable air in a stifling atmosphere.'

In the late seventies Wentworth stopped making sculptures for a while, thinking they had become as dry as broken biscuits. Still he maintains, 'I hate the way I work, the anxiety in waiting for enthusiasm to meet method, material to meet image, idea to meet language.' He is a predator for discarded objects, but he is not as reliant on them as his large junk-yard of a studio implies. 'I think of my studio', he says, 'as the playroom where I'm not told to tidy up, where the order can be imaginative, not typecast.'

There is enough classical structure within Wentworth's work for the Baudelairean rebellion to work. He has a predilection for clean lines. An element of precision is often necessary to balance the anarchic irreverence. 'Like a piece of grit in the shoe', he aggravates to seize the viewer's attention. His social commentary is never straightforward. He is passionately opposed to instant classification and pigeon-holing. Indeed, his work aims to undermine this. It does so by placing the rogue grain of sand in exactly the right spot.

188 *(top left)*
Glad That Things Don't Talk
1982
Rubber, zinc, lead, cable
$13\frac{3}{8} \times 26\frac{3}{4} \times 13$ ($34 \times 68 \times 33$)

189 *(top right)*
Heist (for S.E.)
1983
Linen, duckdown, tinned steel, gilded lead
$23\frac{5}{8} \times 35\frac{3}{8} \times 25\frac{1}{2}$ ($60 \times 90 \times 65$)

190 *(bottom left)*
Yellow Eight
1985
Galvanized steel, brass
$24 \times 12 \times 13$ ($61 \times 30.5 \times 33.2$)

191 *(bottom right)*
Jetsam
1984
Galvanized and enamelled steel, cable
$33\frac{7}{8} \times 29 \times 35\frac{7}{8}$ ($86 \times 74 \times 91$)

192 *(above)*
Siphon
1984–85
Galvanized steel, sponges
$29\frac{1}{8} \times 26 \times 38\frac{7}{8}$ (74 × 66 × 97)

193 *(right)*
Lightweight Chair with Heavy Weights
1983
Laminated wood, steel, brass, lead, cable
$33\frac{7}{8} \times 16 \times 17\frac{3}{8}$ (86 × 41 × 44)

194 *(opposite, left)*
Algebra
1986–87
Wood, vinyl, rubber
$139\frac{3}{4} \times 59 \times 19\frac{5}{8}$ (355 × 150 × 50)

195 *(opposite, top right)*
Prairie
1986–87
Galvanized steel, lead
Suspended: $39\frac{3}{8} \times 35\frac{3}{8} \times 28\frac{3}{8}$
(100 × 90 × 72)

196 *(opposite, bottom right)*
Counting House
1987
Lead, steel, canvas, brass
$55\frac{1}{8} \times 25\frac{1}{2} \times 43$ (140 × 65 × 109)

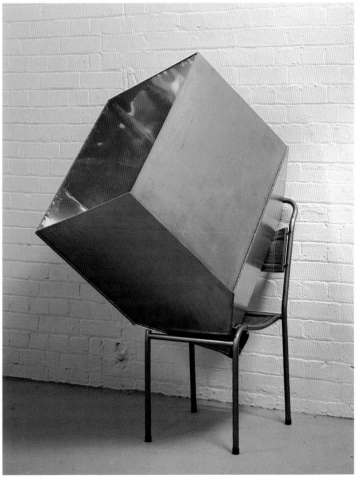

Richard Wilson

It is impossible to warn a visitor to Richard Wilson's *20:50* (1987) of its full impact. It is a room filled with sump oil. Walking down the near-submerged steel bridge, the intruder is wading through the stillest, most silent lake in a land of reflections. Even when reorientated to the physical shock, I wasn't sure whether I was experiencing some piece of latent Baroque illusionism, rejuvenated Dada or something completely new.

Richard Wilson stands apart from the New British Sculptors. The scale and imposing nature of his installations ensure that the public only have rare opportunities to judge his work and these often elicit nervous laughter as people are unprepared for the upheaval of their vision. Yet the sculptor can justifiably claim to be working in one of the longest-established traditions of making art.

The critic Michael Newman traces 'site-specific installations' back to cave paintings and stresses that until the advent of easel painting most art was made for religious buildings. Wilson's transformation of the environment is not totally out of line with the endeavours of the most imaginative eighteenth-century landscape gardeners, though obviously closer to Dada, Arte Povera and Conceptual art. It is Christo with his architectural leanings who perhaps best leads us into Wilson's work.

Wilson makes us re-examine our immediate surroundings, by transforming them. The scale of his works does not usually allow for them to be permanently on view in public spaces, but he no longer preaches the doctrines of Sol LeWitt. He doesn't believe that part of the value of the object lies in its ability to be rebuilt by others. He creates illusions in space, so that we question where and how we live.

There is a Cartesian simplicity about Wilson's work. 'One takes a toy apart to discover its full potential', he says and does the same with rooms. He rebuilds afresh, having first cleared out the standard assumptions about the space. In *She Came In Through The Bathroom Window* at the Matt's Gallery (1989) he removed a large part of a window and then suspended it diagonally from the ceiling, so that it looked as though the window had unhinged part of itself to bite off a large chunk of the room. He connected the gaping hole and the window in its new position by a white, spacious, galleried tunnel. The viewer, who was forced back against the opposite wall, was presented with an area that was not outside and not inside, a no man's land. *20:50* actually has you walking in a similarly unaccountable space, and there is the constant threat of drowning in that black, viscous liquid.

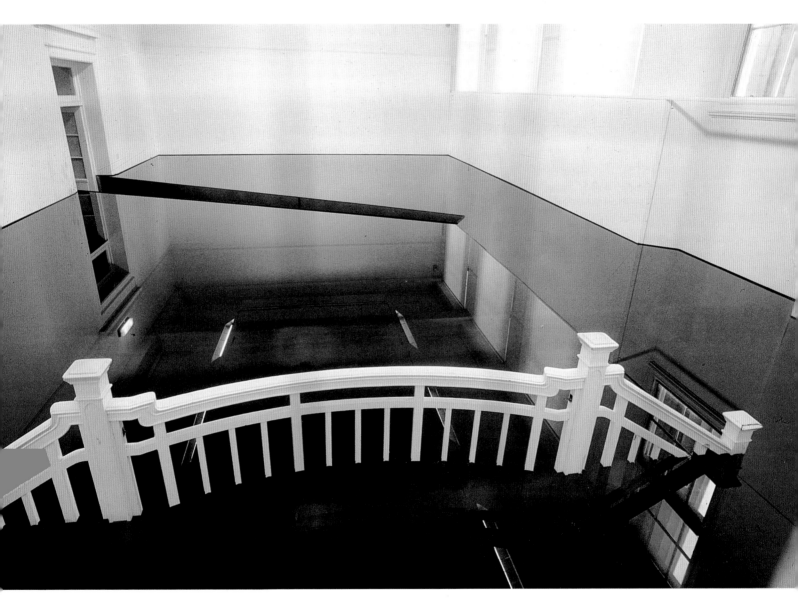

197
20:50
1987
Used sump oil, steel, wood
Installation: Royal Scottish Academy, Edinburgh

Bill Woodrow

Bill Woodrow is the Existentialist hero, not that he would necessarily approve of the compliment. Existentialism is far too long a word for a simple idea and in his sculpture he always expresses himself succinctly and elegantly in the visual equivalent of short, sharp sentences. His work answers its own questions by a stream of unusual juxtapositions from our immediate surroundings. His philosophy and art come naturally from the momentum of his life.

Searching for the Picture (1985) could not be more down-to-earth. Woodrow literally uses a spade and shovel to dig into the television set. He does not set out to be funny; his sense of humour makes his serious comments more digestible. *Self-Portrait in the Nuclear Age* (1986) is grim. A man's severed head orbits the atlas of the world above Australia, while his coat, made of the remains of the Earth in the form of tattered strips of the map, hangs idly above America. The way the head pops out of its frame like a jack-in-the-box is comical, but the message could not be clearer.

Since he studied at St Martin's School of Art from 1968 to 1971, Woodrow's immediate debts have been taken for granted, but the lengthy artistic pedigrees invented for him are more dubious. It is possible to make connections with other twentieth-century artists, such as Picasso, Duchamp and Jasper Johns, but when faced with the work such comparisons do not seem important. Readily identifiable objects are transformed into brightly coloured stories. He is a narrative sculptor and speaks directly to those of his time in a manner similar to that of the painters and sculptors of medieval cathedrals. This does not mean that he offers simple solutions. He is like a mime artist. In looking for a different way to present information he is forced to discover an added and emphatic grace in objects that often previously possessed little.

Woodrow comes into our homes to make us reassess them just as Richard Long asked us to re-examine the landscape. In the late seventies Woodrow showed domestic appliances as contemporary fossils, burying and excavating vacuum cleaners to show how future archaeologists might view us. Since then he has given new life to appliances and machines. With a turn of his wrist he cuts out an animal or instrument, and a washing machine becomes home to a squirrel or starts playing a guitar. His creations leave holes in their parent machines, which help accentuate the new relationships between them.

The man sitting at home in his armchair on a sunny afternoon should find it difficult to ignore Woodrow's art. It is aimed at Everyman's dreams, fantasies and anxieties. In *Washing Machine, Armchair and Car Bonnet with Biombo Mask* (1982) the car bonnet and washing machine have literally fed the creation of a primitive figure in the middle of the living-room. This is not science fiction; it is a comment on the way we live today.

198 *(detail)*, 199
**Washing Machine, Armchair and Car
Bonnet with Biombo Mask**
1982
Washing machine, armchair, car bonnet,
enamel and acrylic paint
Approx. $86\frac{1}{2} \times 122 \times 126$
($220 \times 310 \times 320$)

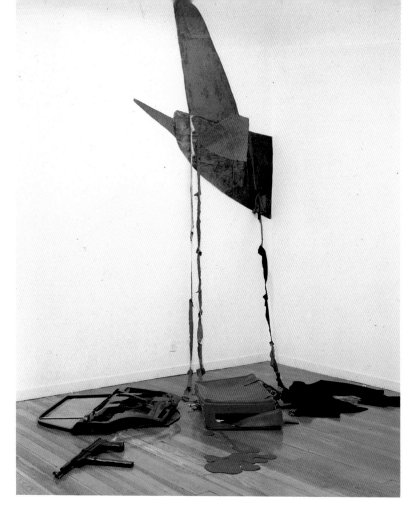

200
Boeing
1983
Car door, clothes, suitcase, enamel paint
71 × 126 × 71 (180 × 320 × 180)

201
Cello Chicken
1983
Two car bonnets
59 × 118 × 118 (150 × 300 × 300)

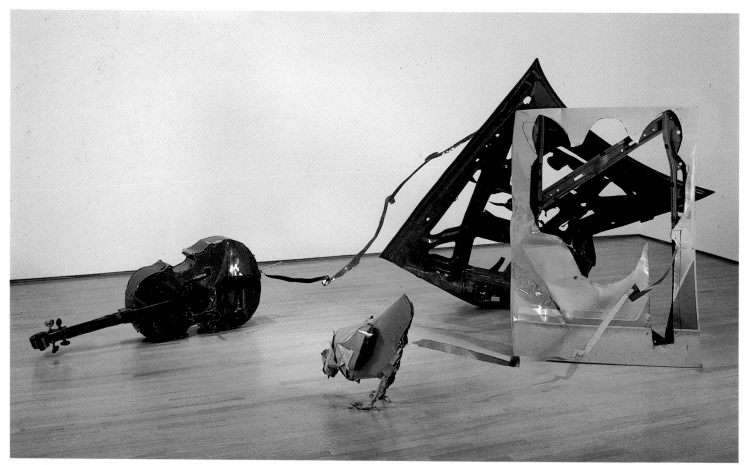

202
Red Squirrel
1981
Electric clothes-drying cabinet, acrylic
paint
$34\frac{1}{4} \times 20\frac{1}{2} \times 18\frac{1}{2}$ (87 × 52 × 47)

203, 204 *(detail)*
Table
1983
Car bonnet, acrylic and spray paint
$43\frac{3}{8} \times 55\frac{1}{8} \times 47\frac{1}{4}$ (110 × 140 × 120)

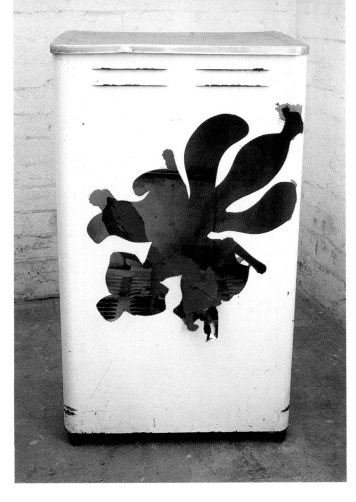

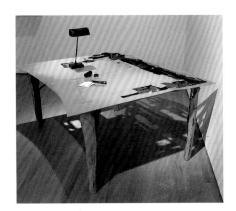

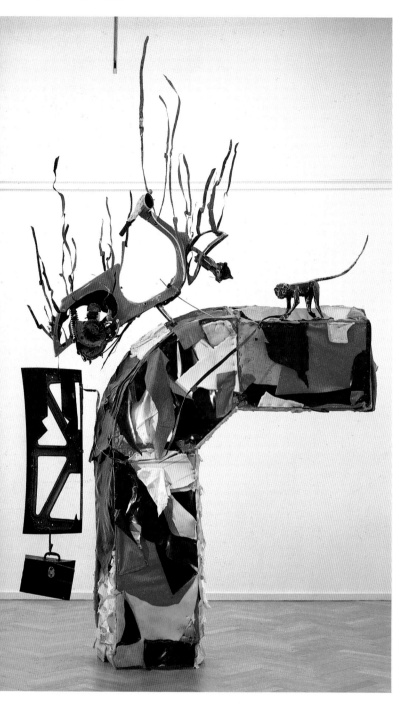

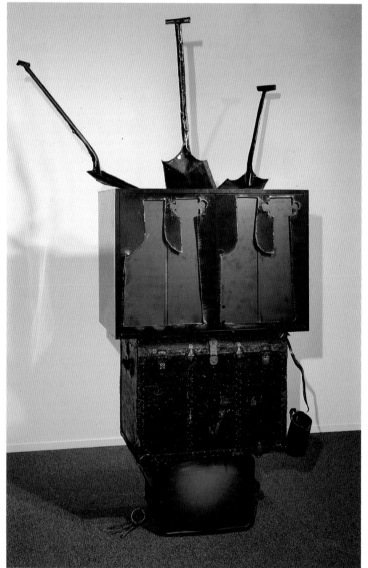

205
Blue Monkey
1984
Couch, motor scooter, car bonnet, metal
box, acrylic paint
$159\frac{3}{8} \times 39\frac{3}{8} \times 118\frac{1}{8}$ (405 × 100 × 300)

206
Searching for the Picture
1985
Television, trunk, office cabinets, spray
paint
$115\frac{1}{2} \times 71 \times 44$ (293.4 × 180.3 × 111.7)

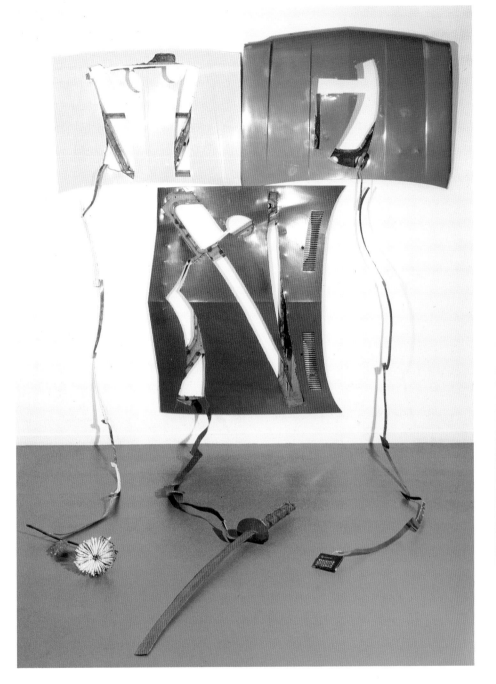

207
Kimono
1983
Car bonnets
98 × 98 × 98 (250 × 250 × 250)

208
Interference
1985
Barbecue trolley, enamel paint
$51\frac{1}{4}$ × $50\frac{1}{4}$ × 27 (130 × 127.5 × 68.5)

209
L'Origine du Tatouage
1983
Three car bonnets, enamel paint
$86\frac{1}{2}$ × 177 × 118 (220 × 450 × 300)

211
Self-Portrait in the Nuclear Age
1986
Shelving unit, wall map, wooden box,
coat, globe, acrylic paint
$78\frac{3}{4} \times 102\frac{3}{8} \times 57$ (200 × 260 × 145)

210
Ship of Fools, Break with the Butcher
1986
Four metal lockers, enamel and acrylic
paint
$135\frac{1}{2} \times 177\frac{1}{8} \times 102\frac{3}{8}$ (344 × 450 × 260)

General Bibliography

Entries are given in order of publication

Bryan Robertson, John Russell and Lord Snowdon, *Private View*, Thomas Nelson, London 1965.

Hayward Gallery catalogue, London 1976, *The Human Clay: An Exhibition Selected by R.B. Kitaj*. Text by R.B. Kitaj.

Rosalind Krauss, *Passages in Modern Sculpture*, Thames and Hudson, London 1977.

Royal Academy of Arts catalogue, London 1981, *A New Spirit in Painting*. Text by Christos Joachimides.

Whitechapel Art Gallery catalogue, London 1981, *British Sculpture in the Twentieth Century*. Selected texts by Lynne Cooke and Fenella Crichton.

Institute of Contemporary Arts, London and Arnolfini, Bristol catalogue 1981, *Objects and Sculpture*. Texts by Lewis Biggs, Iwona Blaszczyk and Sandy Nairne.

Michael Newman, 'New Sculpture in Britain', *Art in America*, September 1982.

Susan Beattie, *The New Sculpture*, Paul Mellon Center for Studies in British Art, Yale University Press, New Haven 1983.

Hayward and Serpentine Galleries catalogue, London 1983, *The Sculpture Show*. Texts by Kate Blacker, Fenella Crichton and Paul Monchaux.

Tate Gallery catalogue, London 1984, *The Hard-Won Image. Traditional Method and Subject in Recent British Art*. Text by Richard Morphet.

Lynne Cooke and Hilton Kramer (on British Artists), *Art of Our Time. The Saatchi Collection*, Lund Humphries, London 1984 and Rizzoli, New York 1985.

Tony Godfrey, *The New Image: Painting in the 1980s*, Phaidon, Oxford 1986.

Frances Spalding, *British Art Since 1900*, Thames and Hudson, London 1986.

Helen Lessore, *A Partial Testament: Essays on Some Moderns in the Great Tradition*, Tate Gallery Publications, London 1986.

Graham Beal, Lynne Cooke, Charles Harrison and Mary Jane Jacob (ed. Terry Neff), *A Quiet Revolution: British Sculpture Since 1965*, Thames and Hudson, London 1987.

Edward Lucie-Smith, *Sculpture Since 1945*, Phaidon, Oxford 1987.

Royal Academy of Arts catalogue, London 1987, *British Art in the 20th Century: The Modern Movement*. Selected texts by Dawn Ades, Richard Cork, Robert Rosenblum and Norman Rosenthal.

Avigdor Arikha, Jean Clair, Timothy Hyman, Michael Peppiatt and Thomas West, 'The School of London', *Art International*, Autumn 1987.

Museum of Modern Art catalogue, Oxford 1987, *Current Affairs. British Painting and Sculpture in the 1980s*. Texts by Lewis Biggs, Andrew Brighton and David Elliott.

Kunstnernes Hus catalogue, Oslo 1987, British Council travelling exhibition, *A School of London: Six Figurative Painters*. Text by Michael Peppiatt.

Royal College of Art catalogue, London 1988, *Exhibition Road: Painters at the Royal College of Art*. Selected texts by Andrew Brighton, Marco Livingstone and Bryan Robertson (ed. Paul Huxley).

Musée des Beaux-Arts catalogue, Le Havre 1988, *Britannica: Trente Ans de Sculpture*. Texts by Françoise Cohen, Lynne Cooke and Catherine Grenier.

Alistair Hicks, *The School of London: The resurgence of contemporary painting*, Phaidon, Oxford 1989.

R.B. Kitaj, *First Diasporist Manifesto*, Thames and Hudson, London 1989.

Biographies

ANDREWS, Michael
Born 1928, Norwich. 1949–53 Slade School of Fine Art. 1952 and 1954 acted in films by Lorenza Mazzetti. 1953 Rome Scholarship in Painting. 1958 first one-man exhibition Beaux Arts Gallery, London. Teaching posts: 1959 Norwich School of Art; 1960 Chelsea School of Art and 1963–66 Slade. 1961 Gulbenkian Purchase Award. 1977 moved to East Anglia. Gallery: Anthony d'Offay, London.
Bibliography:
Hayward Gallery catalogue, London 1980–81, *Michael Andrews*. Text by Lawrence Gowing.
Anthony d'Offay catalogue, London 1986, *Rock of Ages Cleft For Me: Recent paintings by Michael Andrews*. Text by William Feaver.

AUERBACH, Frank
Born 1931, Berlin. 1939 arrived in England. Took evening classes Borough Polytechnic under David Bomberg. 1948–52 St Martin's School of Art and 1952–55 Royal College of Art. 1956 first one-man exhibition Beaux Arts Gallery, London. 1956–68 taught part-time at the Sidcup, Ealing, Bromley, Camberwell and Slade Schools of Art. 1986 represented Britain at Venice Biennale (Golden Lion prizewinner). Gallery: Marlborough Fine Art, London. Lives in London where he has worked in the same studio since 1954.
Bibliography:
Hayward Gallery catalogue, London 1978, *Frank Auerbach*. Texts by Leon Kossoff and Catherine Lampert.
XLII Venice Biennale catalogue 1986, British Council exhibition, *Frank Auerbach Paintings and Drawings 1977–85*. Text by Catherine Lampert.

CAULFIELD, Patrick
Born 1936, London. 1956–60 Chelsea School of Art and 1960–63 Royal College of Art. 1963–71 taught at Chelsea. 1964 exhibited in *New Generation*, Whitechapel Art Gallery, London. 1973 illustrated *The Poems of Jules Laforgue*, Petersburg Press. 1984 designed Michael Corder's ballet *Party Games*, Covent Garden. 1986 selected pictures for 'The Artist's Eye', National Gallery, London. Gallery: Waddington, London. Lives in London.
Bibliography:
Christopher Finch, *Patrick Caulfield*, Penguin, Harmondsworth 1971.
Walker Art Gallery, Liverpool and Tate Gallery, London catalogue, 1981–82, *Patrick Caulfield Paintings 1963–81*. Text by Marco Livingstone.

CRAGG, Tony
Born 1949, Liverpool. 1966–68 laboratory technician National Rubber Producers' Research Association. 1969–72 Wimbledon School of Art and 1973–77 Royal College of Art. 1976 taught at Ecole des Beaux-Arts, Metz. 1977 moved to Wuppertal, West Germany. 1978 began teaching part-time at the Kunstakademie, Düsseldorf, where he was awarded a professorship in 1988. 1988 represented Britain at Venice Biennale and awarded Turner Prize. Gallery: Lisson, London.
Bibliography:
Hayward Gallery catalogue, London 1987, *Tony Cragg*. Text by and interview with Lynne Cooke.
XLIII Venice Biennale catalogue 1988, British Council exhibition, *Tony Cragg*. Texts by Demosthenes Davvetas and Catherine Lampert.

DAVEY, Grenville
Born 1961, Launceston, Cornwall. 1977–81 butcher's apprentice in Exeter. 1981–82 Exeter College of Art and Design and 1982–85 Goldsmith's College, London. Gallery: Lisson, London. Lives in London.
Bibliography:
Stuart Morgan, 'Degree Zero: Grenville Davey', *Artscribe International*, January–February 1988.

DEACON, Richard
Born 1949, Bangor, Wales. 1969–72 St Martin's School of Art and 1974–77 Royal College of Art. 1977 studied history of art at Chelsea School of Art. 1978–79 lived in New York. Since 1979 various teaching posts in England including Chelsea where he still works. 1984 shortlisted for Turner prize, which he was awarded in 1987. 1987 designed sets for *Replacing*, Rambert Dance Company. Galleries: Lisson, London and Marian Goodman, New York. Lives in London.
Bibliography:
Fruitmarket Gallery catalogue, Edinburgh 1984, *Richard Deacon Sculpture 1980–4*. Text by Michael Newman.
Bonnefantenmuseum catalogue, Maastricht 1987, *Richard Deacon Recent Sculpture 1985–7*. Text by Charles Harrison.
Whitechapel Art Gallery catalogue, London 1988–89, *Richard Deacon*. Texts by Marjorie Allthorpe-Guyton and Lynne Cooke.

FREUD, Lucian
Born 1922, Berlin, Germany. 1933 family moved to England. 1939 became naturalized British subject. 1938–39 Central School of Arts and Crafts, 1939–42 Cedric Morris' East Anglian School of Painting and Drawing, Dedham, and 1942–43 Goldsmith's College, London (part-time). 1946–47 painted in Paris and Greece. 1951 awarded Arts Council Prize, Festival of Britain. 1953–54 Visitor, Slade School of Fine Art. 1974 retrospective exhibition at the Hayward Gallery, London. 1983 created Companion of Honour. Represented by James Kirkman, London. Lives in London.

Bibliography:
Lawrence Gowing, *Lucian Freud*, Thames and Hudson, London 1982.
Hirshhorn Museum and Sculpture Garden, Smithsonian Institution, Washington, D.C. 1987 and Hayward Gallery, in association with Thames and Hudson, London 1988 catalogue, *Lucian Freud: paintings*. Text by Robert Hughes.

HODGKIN, Howard

Born 1932, London. 1949–50 Camberwell School of Art and 1950–54 Bath Academy of Art, Corsham. Teaching posts: 1954–56 Charterhouse School; 1956–66 Bath Academy of Art; 1966–72 Chelsea School of Art and 1975–76 Royal College of Art. 1970–76 Trustee of Tate Gallery, London. 1976–77 Artist in Residence, Brasenose College, Oxford. 1977 appointed CBE. 1978 Trustee of National Gallery, London. 1978 selected pictures for 'The Artist's Eye', National Gallery and in 1983 for 'Indian Drawing', Hayward Gallery, London. 1984 represented Britain at Venice Biennale. 1985 awarded Turner Prize. Gallery: Knoedler, New York. Lives in London and Wiltshire.

Bibliography:
Museum of Modern Art catalogue, Oxford 1976, *Howard Hodgkin. Forty-Five Paintings 1949–75*. Text by Richard Morphet.
Bruce Chatwin, *Howard Hodgkin. Indian Leaves*, Petersburg Press, London 1982.
Whitechapel Art Gallery catalogue, London 1985, *Howard Hodgkin. Forty Paintings 1973–84*. Text by John McEwen and interview with David Sylvester.

KITAJ, R.B.

Born 1932, Cleveland, Ohio. 1950–52 studied Cooper Union, New York and Akademie der Bildenden Kunste, Vienna. Early 1950s seaman on American ships. 1956–57 served in US army in Germany and France. 1958–59 Ruskin School of Drawing and Fine Art, Oxford and 1959–61 Royal College of Art, London. 1961–67 various teaching posts in London. 1963 first one-man exhibition Marlborough Fine Art, London, followed by shows in 1965 Los Angeles County Museum of Art, 1967 Stedelijk, Amsterdam and 1970 Kestner-Gesellschaft, Hanover. One-year guest professorships: 1967–68 University of California, Berkeley and 1970–71 University of California, Los Angeles. 1976 organized exhibition 'The Human Clay', Hayward Gallery, London and 1980 selected pictures for 'The Artist's Eye', National Gallery, London. 1984 elected ARA. Gallery: Marlborough Fine Art, London. Lives in London.

Bibliography:
Hirshhorn Museum and Sculpture Garden catalogue, Smithsonian Institution, Washington, D.C. 1981, *R.B. Kitaj*. Texts by John Ashbery, Jane Livingston and Joe Shannon and interview with Timothy Hyman.
Marco Livingstone, *R.B. Kitaj*, Phaidon, Oxford 1985.

KOSSOFF, Leon

Born 1926, London. 1945–48 military service in France, Belgium, Holland and Germany. 1949–53 St Martin's School of Art and evening classes Borough Polytechnic under David Bomberg. 1953–56 Royal College of Art. 1957 first one-man exhibition Beaux Arts Gallery, London. 1973–84 exhibited at Fischer Fine Art, London. Gallery: Anthony d'Offay, London. Lives in London.

Bibliography:
John Berger, 'The Weight', *New Statesman*, 19 September 1959.
Whitechapel Art Gallery catalogue, London 1972, *Leon Kossoff. Recent Paintings*. Text by David Mercer.
Museum of Modern Art catalogue, Oxford 1981, *Leon Kossoff. Paintings from a Decade 1970–80*. Text by David Elliott.
Anthony d'Offay catalogue, London 1988, *Leon Kossoff*. Texts by Lawrence Gowing, Leon Kossoff and Anne Seymour.

MILROY, Lisa

Born 1959, Vancouver, Canada. 1977–78 l'Université de la Sorbonne, Paris, 1978–79 St Martin's School of Art and 1979–82 Goldsmith's College, London. Gallery: Nicola Jacobs, London. Lives in London.

Bibliography:
Nicola Jacobs catalogue, London 1988, *Lisa Milroy*. Text by Ian Jeffrey.
Third Eye Centre catalogue, Glasgow 1989, *Lisa Milroy*. Texts by Lynne Cooke and David Plante.

MORLEY, Malcolm

Born 1931, London. 1952–53 Camberwell School of Arts and Crafts and 1954–57 Royal College of Art. 1958 moved to New York. Teaching posts: 1965–66 Ohio State University, Columbus; 1967–69 School of Visual Arts, New York and 1972–74 State University of New York, Stony Brook. 1977 spent seven months in Berlin through the German Academic Exchange Programme. 1984 awarded first annual Turner Prize. Gallery: Pace, New York. Lives in New York.

Bibliography:
Whitechapel Art Gallery catalogue, London 1983, *Malcolm Morley*. Text by Michael Compton.

MURPHY, John

Born 1945, St Albans, Hertfordshire. 1971 first one-man exhibition Serpentine Gallery, London. Gallery: Lisson, London. Lives in London.

Bibliography:
Lisson Gallery catalogue, London 1985, *John Murphy*. Texts by Barry Barker and Lynne Cooke.
Abbaye Royale de Fontévraud catalogue, Fontévraud 1987, *Ateliers Internationaux des Pays de la Loire*. Text by Didier Semin.
Whitechapel Art Gallery catalogue, London 1987–88, *John Murphy*. Texts by Barry Barker and Michael Newman.

NEWMAN, Avis

Born 1946, London. One-woman exhibitions: 1982 Ikon Gallery, Birmingham, and Matt's Gallery, London; 1985 Galerie Akumaltory 2, Posnan, Poland and 1988 Renaissance Society, University of Chicago. Gallery: Lisson, London. Lives in London.

Bibliography:
Lisson Gallery catalogue, London 1987, *Avis Newman*. Text by Jean Fisher.

Independent Curators Inc. catalogue, New York 1987–88, *The Analytical Theatre: New Art from Britain*. Selected text by Michael Newman.

OPIE, Julian
Born 1958, London. 1979–82 Goldsmith's College. 1985 one-man exhibitions at Groninger Museum, Groningen and Institute of Contemporary Arts, London. Gallery: Lisson, London. Lives in London.
Bibliography:
Kölnischer Kunstverein catalogue, Cologne 1984, *Julian Opie*. Texts by Kenneth Baker and Wulf Herzogenrath.
Lisson Gallery catalogue, London 1988, *Julian Opie*. Text by Michael Newman.

REGO, Paula
Born 1935, Lisbon, Portugal. 1952–56 Slade School of Fine Art. 1957–63 lived in Ericeira, Portugal. 1962–63 received a bursary from the Gulbenkian Foundation, Lisbon. 1963–67 lived in London. 1967–75 lived in Portugal with visits to London. 1976 settled permanently in England. 1983 Visiting Lecturer, Slade. 1988 retrospective exhibition, Gulbenkian Foundation. Gallery: Marlborough Fine Art, London. Lives in London.
Bibliography:
Germaine Greer, 'Paula Rego', *Modern Painters*, Vol.1, no.3, Autumn 1988.
Serpentine Gallery catalogue, London 1988, *Paula Rego*. Texts by Ruth Rosengarten, Victor Willing and interview with John McEwen.

SCULLY, Sean
Born 1945, Dublin, Ireland. 1949 family moved to London. 1965–68 Croydon College of Art, 1968–72 Newcastle University and 1972–73 Harvard University, Cambridge, Massachusetts on a Frank Knox Fellowship. 1973–75 taught at Chelsea School of Art and Goldsmith's College, London. 1975 moved to America, becoming naturalized in 1983. 1977–83 taught at Princeton University, New Jersey. 1983 awarded Guggenheim Fellowship. 1984 received Artist's Fellowship from the National Endowment for the Arts. Galleries: Mayor Rowan, London and David McKee, New York. Lives in New York and London.
Bibliography:
Ikon Gallery catalogue, Birmingham 1981, *Sean Scully: Paintings 1971–1981*. Text by Joseph Masheck.
Carnegie Institute catalogue, Pittsburgh 1985, *Sean Scully*. Texts by John Caldwell, David Carrier and Amy Lighthill.
Whitechapel Art Gallery catalogue, London 1989, *Sean Scully: Paintings and Works on Paper 1982–88*. Text by Carter Ratcliff.

WEIGHT, Carel
Born 1908, London. *c*.1928–30 Hammersmith College of Art and *c*.1930–33 Goldsmith's College (part-time). 1931 first exhibited at the Royal Academy of Arts, London. 1945–46 Official War Artist, travelling to Italy, Austria and Greece. From 1947 taught at Royal College of Art where between 1957–73 he was Professor of Painting. Elected ARA 1955 and RA 1965. 1962 awarded CBE. 1963 commissioned to paint mural *Christ and the People* for Manchester Cathedral. 1968 illustrated the *Oxford Illustrated Old Testament*. 1975–84 Trustee of Royal Academy of Arts. 1983 appointed Senior Fellow, Royal College. Lives in London.
Bibliography:
Royal Academy of Arts catalogue, London 1982, *Carel Weight, A Retrospective Exhibition*. Text by Ruskin Spear and interview with Norman Rosenthal.
Mervyn Levy, *Carel Weight*, Weidenfeld and Nicolson, London 1986.

WENTWORTH, Richard
Born 1947, Samoa/Cambridge. 1966–70 Royal College of Art. 1967 assisted Henry Moore. 1974 awarded Mark Rothko Memorial Award. 1971–88 taught at various art schools including Goldsmith's College. 1978 lived in New York. Gallery: Lisson, London. Lives in London.
Bibliography:
Lisson Gallery catalogue, London 1986, *Richard Wentworth. To the Oddworkers*. Text by Ian Jeffrey.
Riverside Studios catalogue, London 1987, *Richard Wentworth*. Text by Greg Hilty and interview with Milena Kalinovska.
Sala Parpallo catalogue, Valencia, Spain 1988, *Richard Wentworth, Coleccion Imagen*. Text by Juan Vincente Aliga and interview with Paul Bonaventura.

WILLING, Victor
Born 1928, Alexandria, Egypt. 1932 family returned to England. 1949–54 Slade School of Fine Art. 1955 first one-man exhibition Hanover Gallery, London. 1957–63 lived in Ericeira, Portugal. 1963–67 lived in London. 1967–75 lived in Portugal with visits to London. 1976 settled permanently in England. 1980 received Thorne Scholarship. 1982–83 Artist in Residence, Corpus Christi College and Kettle's Yard, Cambridge. Died 1988.
Bibliography:
Whitechapel Art Gallery catalogue, London 1986, *Victor Willing. A Restrospective Exhibition 1952–85*. Text by Lynne Cooke and interview with John McEwen. Writings by Victor Willing with introductory note by David Sylvester.

WILSON, Richard
Born 1953, London. 1970–71 London College of Printmaking, 1971–74 Hornsey College of Art and 1974–76 Reading University. Selected installations: 1987, *20:50*, Matt's Gallery, London and *One Piece at a Time*, for TSWA 3D, Tyne Bridge, Newcastle and 1989, *Leading Lights*, Kunsthallen Brandts Klaedefabrik, Odense, Denmark. Gallery: Matt's, London. Lives in London.
Bibliography:
Matt's Gallery, London, Museum of Modern Art, Oxford and Arnolfini, Bristol, 1989, catalogue for an exhibition of three site-specific sculptures, *Richard Wilson*. Text by Michael Newman.

WOODROW, Bill
Born 1948, Henley, Oxfordshire. 1968–71 St Martin's School of Art and 1971–72 Chelsea School of Art. 1972 first one-man exhibition Whitechapel Art Gallery, London. Selected

museum exhibitions: 1984 Musée de Toulon; 1985 Kunsthalle, Basel and 1987 Kunstverein, Munich. 1985 Artist in Residence, La Jolla Museum of Contemporary Art, California. Gallery: Lisson, London. Lives in London.
Bibliography:
Mark Francis, 'Bill Woodrow: Material Truths', *Artforum*, January 1984.

Fruitmarket Gallery catalogue, Edinburgh 1986, *Bill Woodrow. Sculpture 1980–6*. Text by Lynne Cooke.
Musée des Beaux-Arts catalogue, Le Havre 1989, *Bill Woodrow. Eye of the Needle. Sculptures 1987–9*. Texts by Françoise Cohen and Catherine Grenier.

Index

Artists and works in the Collection are indexed. Illustration numbers are given in italics.

Andrews, Michael 11, 13, 14, 22, 114
 The Cathedral, North-East Face 22, 2
 Laughter 22, 1
 Permanent Water 22, 3
Auerbach, Frank 7, 9, 11–13, 26–7, 108, 150
 The Chimney – Mornington Crescent 14
 E.O.W. III 27, 7
 Figure on a Bed 26, 13
 Head of J.Y.M. 26, 11
 J.Y.M. Seated 12
 Looking Towards Mornington Crescent Station – Night 6
 Primrose Hill 26, 4
 Railway Arches, Bethnal Green II 8
 Rimbaud II 9
 Summer Building Site 5
 To the Studio 10
Caulfield, Patrick 9, 34, 108
 Fish and Sandwich 34, 16
 Foyer 34, 15
 Glass of Whisky 34, 17
 Lunchtime 34, 18
Cragg, Tony 8, 16–19, 122–3
 Brick Built 150
 Città 148
 Evensong 122, 146
 Eye Bath 144
 Instinctive Reactions 123, 149
 Inverted Sugar Crop 145
 Minster 19, 122, 152
 Riot 147
 Sermon 122, 140
 Spectrum 141, 142
 Stack 139
 Tools 143
 Untitled (Conch shell) 122, 151
Davey, Grenville 132
 Cover 132, 155
 Grey Seal 132, 159
 Purl 132, 158
 Quad 160
 Rail 156
 Red Giant 157
 Seal 154
 Untitled Pair 153
Deacon, Richard 8, 9, 16, 17, 19, 94, 132, 136–7
 Art For Other People 136; No. 2, 162; No. 5, 165; No. 9, 173, 174
 The Back of My Hand No. 6 179
 Fish Out of Water 178
 For Those Who Have Ears No. 1 137, 170
 For Those Who Have Eyes 137, 171

 The Heart's in the Right Place 168, 169
 If The Shoe Fits 136, 163
 Out of the House 166, 167
 Tall Tree in the Ear 175
 This, That and the Other 177
 Turning a Blind Eye 176
 Two Can Play 172
 Untitled (1980) 136, 161
 Untitled (1981) 136, 164
Freud, Lucian 7, 11, 12, 38
 Blonde Girl on a Bed 38, 26
 Dead Bird 20
 Dead Monkey 23
 Girl Sitting 38, 27
 Hand Puppet 21
 Naked Man on a Bed 12, 38, 24
 Night Interior 19
 The Spotted Jacket 22
 Woman in Grey Sweater 25
Hodgkin, Howard 7, 11, 14, 15, 46–7
 After Dinner at Smith Square 47, 33
 Blue Evening 34
 Clean Sheets 47, 36
 Dick and Betsy Smith 47, 31
 Family Group 35
 Girl in Bed 30
 Haven't we met? 39
 A Henry Moore at the Bottom of the Garden 38
 Interior with Figures 41
 Menswear 47, 40
 Mr and Mrs Robyn Denny 47, 28
 114 Sinclair Road 46, 29
 Paul Levy 37
 Portrait of Mr and Mrs Kasmin 32
Kitaj, R.B. 7, 9, 11, 12, 46, 56, 108
 The Corridor (After Sassetta) 12, 56, 46
 The Drivist 12, 44
 Germania (Vienna) 56, 45
 The Neo-Cubist 12, 56, 42
 The Sniper 43
Kossoff, Leon 7, 11–13, 60–61, 108
 Breakfast 56
 Children's Swimming Pool, 11 o'clock Saturday Morning, August 1969 53
 Dalston Junction Ridley Road Street Market, Stormy Morning 52
 Double Self-Portrait 49, 50
 Family Party, January 1983 57
 Here Comes the Diesel, Early Summer 1987 60, 62
 Inside Kilburn Underground, Summer 1983 58
 Nude on a Red Bed 51
 Portrait of Father III 48
 Portrait of Philip Kossoff I 54
 School Building, Willesden, May 1983 60
 School Building, Willesden, Spring 1981 59
 A Street in Willesden 61, 61

Two Seated Figures I 55
Woman ill in Bed 47
Milroy, Lisa 9, 72
 Dresses 63
 Fans 72
 Greek Vases 67
 Japanese Prints 65
 Pulleys, Handles, Castors, Locks, and Hinges 75
 Regiment 64
 Roman Coins 68
 Row of Shoes (1985) 69
 Sailors' Caps 72, 66
 Shoes (1985) 70
 Shoes (1986) 71
 Silverware 73
 Tyres 74
Morley, Malcolm 9, 15, 80, 108
 Age of Catastrophe 81
 Arizonac 83
 Camels and Goats 80, 82
 Farewell to Crete 80, 84
 Love Boat 85
 Macaws, Bengals, with Mullet 86
 School of Athens 78
 SS Amsterdam in Front of Rotterdam 80, 76
 SS France 80, 80
 Untitled Souvenirs, Europe 80, 79
 Vermeer, Portrait of the Artist in his Studio 80, 77
Murphy, John 9, 72, 88
 And the Tongue, And the Throat 88, 93
 I have carved you on the palm of my hand 88, 96
 An Indefinable Odour of Flowers Forever Cut 87
 'In my throat', said the Moon 88, 92
 Let him feel the Tongues of Longing 88, 95
 The Nocturnal Inscription Represents . . . 88
 A Null Jewell of Reverie (Epidendrum brassavolae) 88, 89
 The Shallow Ear Quickly Overflows 91
 Stuck in the Milky Way 90
 Warm Explosion in My Black Siberia 94
Newman, Avis 9, 94, 102
 Figure who no one is . . . 88, 97–101
Opie, Julian 16, 20, 21n, 146
 Ceasefire (Black III) 146, 183
 F 187
 G 186
 J 184
 Man Accused of Murder 146, 180
 Nightlight 185
 Soviet Frost (White II) 146, 182
 Stock Market 146, 181
Rego, Paula 14, 15, 98, 114
 The Family 105

Looking Back 102
The Maids 98, 104
The Policeman's Daughter 103
Scully, Sean 9, 15, 46, 102
 All There Is 102, 112
 The Bather 102, 106
 By Night and By Day 107
 Empty Heart 113
 Heat 111
 No Neo 102, 114
 Outback 108
 Red Earth 110
 Standing 109
Weight, Carel 9, 108
 The Bag Snatcher 108, 121
 Bid for Freedom 108, 117
 Crucifixion II 119
 The Dream 108, 120
 Foxwood 115
 Guardian Angel 118
 Invasion 123
 Primavera 124
 Thoughts of the Girls 116
 Winter Walk 122
Wentworth, Richard 8, 16–18, 20, 21n, 132, 150
 Algebra 194
 Counting House 196
 Glad That Things Don't Talk 18, 188
 Heist (for S.E.) 189
 Jetsam 150, 191
 Lightweight Chair with Heavy Weights 193
 Prairie 195
 Siphon 192
 Yellow Eight 190
Willing, Victor 7, 11, 14, 114
 Callot Fusilier 114, 132
 Callot Harridan 114, 131
 Griffin 114, 129
 Heads 114; No. 1, 133; No. 3, 134; No. 5, 135; No. 7, 136; No. 8, 137; No. 9, 138
 Höhle 127
 Knot 130
 Navigation 114, 125
 Plants 126
 Tatters 114, 128
Wilson, Richard 9, 154
 20:50 154, 197
Woodrow, Bill 8, 16–20, 21n, 156
 Blue Monkey 205
 Boeing 200
 Cello Chicken 201
 Interference 208
 Kimono 207
 L'Origine du Tatouage 209
 Red Squirrel 202
 Searching for the Picture 156, 206
 Self-Portrait in the Nuclear Age 156, 211
 Ship of Fools, Break with the Butcher 210
 Table 203, 204
 Washing Machine, Armchair and Car Bonnet with Biombo Mask 156, 198, 199